IMAGES
of America

CEMETERIES OF
SAN DIEGO

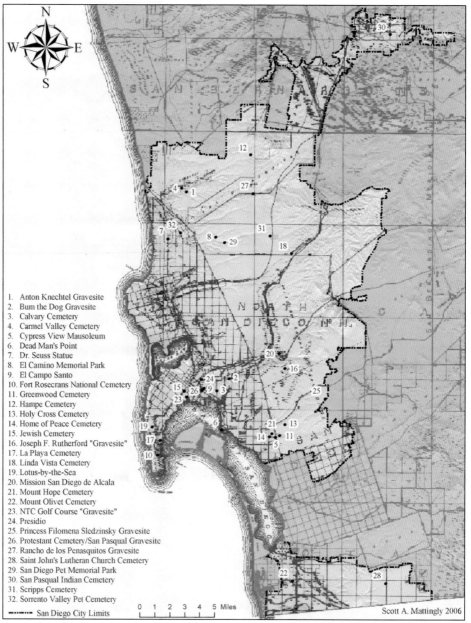

1. Anton Knechtel Gravesite
2. Bum the Dog Gravesite
3. Calvary Cemetery
4. Carmel Valley Cemetery
5. Cypress View Mausoleum
6. Dead Man's Point
7. Dr. Seuss Statue
8. El Camino Memorial Park
9. El Campo Santo
10. Fort Rosecrans National Cemetery
11. Greenwood Cemetery
12. Hampe Cemetery
13. Holy Cross Cemetery
14. Home of Peace Cemetery
15. Jewish Cemetery
16. Joseph F. Rutherford "Gravesite"
17. La Playa Cemetery
18. Linda Vista Cemetery
19. Lotus-by-the-Sea
20. Mission San Diego de Alcala
21. Mount Hope Cemetery
22. Mount Olivet Cemetery
23. NTC Golf Course "Gravesite"
24. Presidio
25. Princess Filomena Sledzinsky Gravesite
26. Protestant Cemetery/San Pasqual Gravesite
27. Rancho de los Penasquitos Gravesite
28. Saint John's Lutheran Church Cemetery
29. San Diego Pet Memorial Park
30. San Pasqual Indian Cemetery
31. Scripps Cemetery
32. Sorrento Valley Pet Cemetery

------- San Diego City Limits

0 1 2 3 4 5 Miles

Scott A. Mattingly 2006

NINETEENTH-CENTURY MAP OF SAN DIEGO. M. C. Wheeler Company's 1872 "Official Map of the Western Portion, San Diego County, California" serves as the backdrop for the exact locations of each of the 32 cemeteries, grave sites, and mortuary myths discussed in this book. Only about half of the city's actual cemeteries still exist above ground (11 out of 23), and less than a third (7 of 23) are still active. (Courtesy South Coastal Information Center [SCIC].)

ON THE COVER: Father Ubach presides over the 1905 burial of 35 sailors from the USS *Bennington* at the U.S. Army's Post Cemetery, San Diego Barracks (Point Loma). This cemetery would become Fort Rosecrans National Cemetery in 1934. (Courtesy San Diego Historical Society [SDHS].)

IMAGES
of America

CEMETERIES OF
SAN DIEGO

Seth Mallios and David M. Caterino

ARCADIA
PUBLISHING

Published by Arcadia Publishing
Charleston, South Carolina

Printed in the United States of America

Library of Congress Catalog Card Number: 2006934437

For all general information contact Arcadia Publishing at:
Telephone 843-853-2070
Fax 843-853-0044
E-mail sales@arcadiapublishing.com
For customer service and orders:
Toll-Free 1-888-313-2665

Visit us on the Internet at www.arcadiapublishing.com

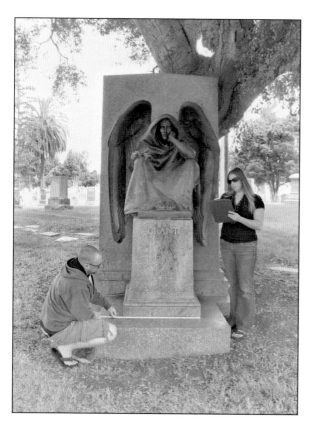

THE SAN DIEGO GRAVESTONE PROJECT. San Diego State University students Scott Mattingly and Hillary Sweeney record details from the bronze Angel of Death that marks the grave of the 18th president's son in Greenwood Memorial Park. With all due respect to Groucho Marx, there is no riddle behind the contents of this plot; Ulysses S. Grant Jr. *is* interred in Grant's tomb. Dr. Seth Mallios directs the San Diego Gravestone Project, which began in 2002, and David M. Caterino supervises the fieldwork. (Courtesy SCIC.)

CONTENTS

Acknowledgments		6
Introduction		7
1.	Mission Cemeteries	11
2.	Pioneer Cemeteries	25
3.	Mega-Cemeteries	63
4.	Military Cemeteries	103
5.	Cemetery Myths	111
6.	Gravestone Trends	119
Conclusion		123
Bibliography		126
Index		127

ACKNOWLEDGMENTS

The San Diego Gravestone Project is a team effort that has benefited from the insight, dedication, and hard work of numerous individuals. The authors extend their sincere appreciation to the following people for their contributions: Kristi Hawthorne, Heather Thomson, Dr. Lynne Christenson, Carrie Gregory, Jeannie Gregory, Barb Giacomini, James Harper, Ruth Ochoa, Stan Berryman, Noah Stewart, Rich Borstadt, Andy Yatsko, Norm and Kathy Feigel, Steve Van Wormer, Andrew Pigniolo, Patrick McGinnis, Tracy Nelson, Ron May, Wayne Taylor, Chet Taylor, Tom and Nancy Wilson, George White, Dan Galligan, ranger Jennifer Miller, Debbie Moretti, Nelda Taylor, Monica Guerrero, Al Gettman, Jerry Schaefer, Jacque Beck, Mary Beth Hayashi, Jim Kemp, Mick Calarco, David Lewis, Joan Miller, Eagle Scout Karl Miller and his troop along with family and friends, Harold Williams, Lynn and "Santa" Creager, Vernon Montoya, Wayne Mills, Woody Kirkman, Dan McManama, Mabel Carlson, Joyce Pelkey, Jan McDonald, Clint Griffin, Jack Mathias, Ray Snider, ranger Pat Valenta, Kathy Peck, Shane Emmett, Julie Armour, Hillary Sweeney, Jaime Lennox, Scott Mattingly, Jai Bastian, Chris Collins, Bill Arballo, Hortensia Trejo, Bob Mitchell, Norman Blackwood, Peggy Haleen of Seaman-Poe Monument Company, Frankie of Clemens Granite Works, and Berry-Bell and Hall Mortuary. In addition, many San Diego State University graduate and undergraduate students—supported by Professor Mallios's 2003–2004 SDSU faculty grant-in-aid and facilitated through his fall 2002 Anthropology 580, spring 2003 Anthropology 312/560, and summer 2004 Anthropology 312/560 classes—recorded gravestone information and performed data entry. Jason Durbin constructed the elaborate Microsoft Access database central to the San Diego Gravestone Project, Ginger Stockdale kindly supplied her computer talents and additional software at a moment's notice, and Anna DeYoung was Professor Mallios's research assistant in 2005–2006. The authors are also grateful to Arcadia editors Jerry Roberts and Deborah Seracini for helping to make this book a reality. And lastly, this book about San Diego's past is dedicated to the city's newest native occupant, Gabriella Eireen Mallios.

INTRODUCTION

"America's Finest City," as San Diego has come to be known, is home to more than a million living inhabitants and perhaps 500,000 deceased. The city's rich multicultural history and dynamic identity is reflected in its 23 cemeteries, but so is its struggle with rampant development. Of those nearly two dozen historic cemeteries, less than 50 percent still exist above ground. In the case of the others, many of the gravestones have been stolen, buried, or separated in some other unceremonious manner from the bodies they once marked. Perhaps an inevitable consequence of growing to be the nation's eighth-largest city is a loss of touch with its humble origins and a lack of appreciation for its history. Former English prime minister William Ewart Gladstone asserted over a century ago, "Show me the manner in which a nation or community cares for its dead, and I will measure with mathematical exactness the tender sympathies of its people, their respect for the laws of the land and their loyalty to high ideals." The tales of San Diego's cemeteries that fill the following pages are decidedly split. As a group, they are simultaneously tender and callous, reverent and disgraceful, honorable and illegal. For every one of the many heartwarming stories about the local citizenry opting to preserve history in the face of expansion, there are counter-examples of rampant grave-marker theft and vandalism. The ongoing ambiguity in San Diego's relationship with its history is never more apparent than in its tumultuous treatment of its dead. One cannot help but wonder: Can San Diegans collectively balance their love of the present and their drive for the future with an appropriate respect for the past?

This book discusses cemeteries within San Diego's current city limits. However, the city landscape, consisting of eight large neighborhoods (Northern, Northeastern, Eastern, Western, Central, Mid-City, Southeastern, and Southern) is far from straightforward. The city has large non-city pockets (Chula Vista and Coronado are not part of San Diego, yet they are mostly surrounded by it) and far-reaching fingers (San Pasqual to the northeast and Otay Mesa to the south). It is centrally located about Mission Valley and stretches intermittently all the way from the Mexican border to Escondido (see page 2). Contiguous San Diego is bounded by Del Mar, Rancho Santa Fe, and Escondido to the north, and Poway, Santee, and El Cajon to the east. Southern San Diego is isolated from San Diego proper by Chula Vista and Coronado and is bounded to the south by Mexico. Even though the city limits have changed over time, this book uses San Diego's official boundaries at the start of the 21st century as its area of study.

San Diego has a long and intricate history. It has been home to an indigenous population with multiple tribal affiliations, including the Kumeyaay, Luiseño, Cupeño, and Cahuilla for approximately 7,000 to 10,000 years. This area of coastal land clustered about the 33rd parallel of north latitude was first explored by Europeans in 1542 by Spaniard Juan Rodriguez Cabrillo. Although Cabrillo's venture came only 50 years after Columbus's inaugural trek to the Americas, no other Westerners would land in the area until Sebastian Vizcaino's visit in 1602. Vizcaino's landing preceded another hiatus; history recorded no European entry into the region again until

Franciscan missionary Fr. Junipero Serra began a northward expansion of Spain's mission system in 1769. This first substantive European presence in San Diego, the Spanish Mission Period, lasted from 1769 to 1821. During these years, clerics and soldiers established a joint mission and presidio military compound in 1769, moved the mission upstream in the 1770s to access a more reliable water venue, and completed Padre Dam by 1816. Mexico's independence from Spain in 1821 marked the start of San Diego's 27-year Mexican Period. These years witnessed the secularization and stagnation of the missions and the land granting of numerous ranchos to the close friends of high-ranking local Mexican officials. The United States acquired California as a result of war with Mexico in the late 1840s and soon thereafter established the state's first official county at San Diego in 1850. This Early American Period, from 1848 to 1880, saw little growth for the region, although it included harbingers of the good times to come in the form of the creation of New Town in 1867 and the 1870 Julian gold rush. During San Diego's Victorian Period, from 1880 to 1907, the area burgeoned with railroads, international expositions, a downtown business center, and an elaborate system of irrigated agriculture. The years from 1908 to 1945, San Diego's Air and Sea Period, saw tremendous expansion of both military and commercial navigation centers, including the creation of various naval bases and the building of Charles Lindbergh's the *Spirit of St. Louis*. And finally, the current Modern Period, starting in 1946, has witnessed spectacular growth for "America's Finest City."

Even though California Native Americans occupied the area that would become San Diego for thousands of years before European arrival, this text begins with the cemeteries of 18th-century Spanish explorers and missionaries. There are thousands of Native American burials in the region, yet few are included in this text. The reason for this is simple: an overwhelming majority of these indigenous mortuary remains are part of prehistoric archaeological sites whose location must remain undisclosed to the general public for fear of looting. It would be highly ironic to lament the loss of history in a book that undermines preservation of the past. The location of these archaeological mortuary sites, in accordance with standards set forth by the secretary of the interior and others, will continue to remain confidential. However, California Native Americans who were buried in established mission cemeteries during subsequent Spanish, Mexican, and Early American Periods are included and discussed in this study.

San Diego's cemeteries come in many forms and, for the most part, change over time in a standardized manner. Spanish mission cemeteries were located close to the church. Following European traditions, missionaries buried their dead in sacrosanct churchyards according to specific spatial norms that tied directly to their faith in resurrection. Across Europe and in early Colonial America, wealthy and elite individuals were interred within the church itself and on the east side in order to get the most direct view of the rising sun on Judgment Day. The poor were laid to rest to the south of the church, while the north churchyard was reserved for stillborns, bastards, and individuals who committed suicide. Even though these shallow churchyards often teemed with scattered bones, scavenging animals, and maggots, they were still a center of social activity. In San Diego, nearly every Spanish mission grave was initially marked with wooden crosses, and the perimeter of the individual burial plot was delineated with a white picket fence. During the Mexican Period, many of the mortuary traditions remained the same. Stone markers began to replace wooden crosses, but overall these two periods were culturally consistent in terms of mortuary placement and display. The pioneer cemeteries of the Early American Period were strikingly different. These late–19th century graveyards were very diverse. Some were in populated areas; others were located in remote areas. Their grave markers varied as well, as pioneer cemeteries often contained a blend of standardized gravestones (wooden crosses or marble statues and tablets) and rustic locally made grave markers. San Diego's Victorian Period saw the rise of the Rural or Garden Cemetery Movement. Again mimicking European mortuary trends, graveyards were moved from city centers to areas far out of town. Following the example of Paris's Père Lachaise, which spans hundreds of acres in an uninterrupted picturesque landscape and is far away from the church and the crowded urban interior, San Diego's Mount Hope Cemetery was the first expansive rural garden graveyard. Although the grave markers varied in form at first,

by the middle of San Diego's Air and Sea Period, gravestones had become largely standardized flush markers. In fact, some of the newest cemeteries established during the Modern Period allow no other type of grave marker.

Regardless of cemetery form, this book discusses all local post-Contact graveyards, as long as they are in San Diego and mark the location of the deceased. Although much debate and contradictory legislation exists over how many burials a cemetery must have in order to be considered a cemetery (1, 3, 12, etc.), this text uses a loose definition of cemeteries and graveyards. As far as the San Diego Gravestone Project is concerned, one grave makes a graveyard. Roadside memorials, however, are left for another book, as they do not mark the location of the deceased but the locus of death. Furthermore, as poetic as it would be to identify Qualcomm Stadium as a cemetery (ask the Raiders about Superbowl XXXVII), this book sticks to more conservative definitions of cemeteries as literal burying grounds that may or may not contain some sort of above-ground marker to commemorate the deceased.

Contrary to the popular maxim, one must not miss the trees for the forest either. Individual burials make up the cemeteries, and it is imperative that their stories are not lost in general discussions of funerary trends. This book endeavors to capture many personal stories of San Diego's dead. Nearly every cemetery presented in this text is followed with brief biographies of some of the individuals who are interred there. These stories sample two and a half centuries of local history, presenting a remarkably diverse mix of public servants, entrepreneurs, soldiers, athletes, artists, intellectuals, criminals, and the town dog. The list is by no means comprehensive, but it is somewhat representative of the city's legacy. Since the following pages draw on existing historical records, it is inevitably biased in favor of the wealthiest and most powerful individuals of the time. Women and people of color are underrepresented in the annals of San Diego history, yet they nonetheless have had a great impact on the city, and many of their contributions are detailed here.

This book is divided into six chapters, each of which emphasizes a different kind of cemetery or analysis. Chapter One details the city's four mission and Mexican Period cemeteries: the Presidio, Dead Men's Point (*La Punta de los Muertos*), Mission San Diego de Alcalá, and San Pasqual Indian Cemetery. These graveyards contain individuals of a variety of ethnicities, yet their overall layout reflects a missionary design, typically placing the burials in close proximity to the church. The second chapter focuses on the city's 14 pioneer cemeteries: La Playa, El Campo Santo, Protestant, Jewish, Calvary, Rancho de los Peñasquitos, Linda Vista, Saint John's Lutheran, Mount Olivet, Carmel Valley, Anton Knechtel, Hampe Family, Lotus-by-the-Sea, and Scripps. Most of the individuals interred in these graveyards were buried during the Early American Period. Chapter Three describes San Diego's five mega-cemeteries: Mount Hope, Home of Peace, Greenwood, Holy Cross, and El Camino. Although this title is a bit of a misnomer ("mega" means million, and these graveyards typically and currently accommodate fewer than 100,000 people), the rise of gigantic sprawling cemeteries was common in the years leading to San Diego's Victorian Period. Boston's Mount Auburn cemetery, established in 1831, was the first graveyard in the Western hemisphere to embrace this change toward large rural garden cemeteries that persists into the present day, but San Diego's Mount Hope (1869) was not far behind. The fourth chapter discusses the city's military cemetery at Fort Rosecrans. Military mortuary practices reflect the discipline and standardization that rules the armed services. The gravestones are nearly identical to one another, and the spatial layout of Fort Rosecrans is paralleled by every other national military cemetery in the United States. Chapter Five unravels some of San Diego's fanciful cemetery myths. It details both the elaborate lore and the actual location of the remains of local icons, such as Dr. Seuss, Polish Princess Filomena Sledzinksi, and Bum the Dog. The sixth chapter explores patterns in San Diego; it shows how the region's mortuary art is both similar to the national pattern and regionally distinctive. For example, local grave markers get smaller and smaller over time in such a regular fashion that it is possible to deduce the date of an unmarked gravestone from its height. And lastly, the book concludes with a brief discussion of the interconnectedness among past San Diegans and between historic San Diego and the current metropolis. This connection

is both a blessing and a burden; it reveals a deep unity among local inhabitants across time, but it also demands acknowledgment, appreciation, and reverence for those who preceded us. A city is its people, past and present. As a result, this book is as much about San Diego's living as it is about its dead.

One

MISSION CEMETERIES

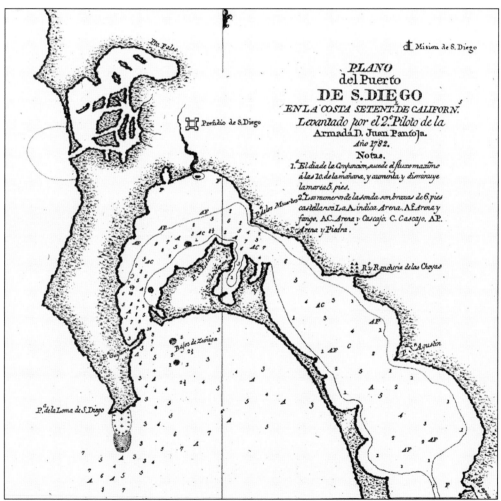

1782 PANTOJA MAP OF "PUERTO DE S. DIEGO." Spanish pilot Juan Pantoja y Arriaga's 18th-century survey map of the San Diego Bay includes the exact location of three of the city's four mission-period cemeteries: "Presidio d. San Diego," "P. de los Muertos," (Dead Men's Point), and "Mission d. San Diego." (Courtesy SCIC.)

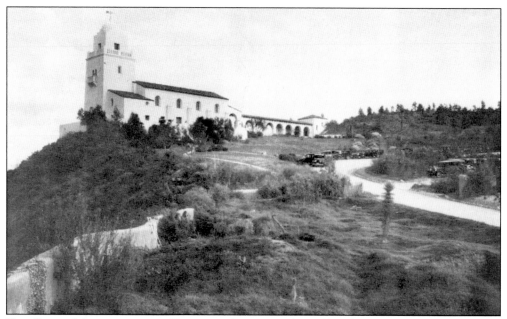

THE SERRA MUSEUM AT THE PRESIDIO. Constructed in 1929, the Serra Museum overlooks Highway 8 and Taylor Street. It stands just above the location of the original Spanish Presidio. Before "Presidio Hill" became a fort, it was a burial ground; more than 60 individuals who died during the Sacred Expedition of 1769 were buried there. From the Presidio, one could see the San Diego River and Bay and the Indian village of *Cosoy*. (Courtesy San Diego State University Special Collections [SDSUSC].)

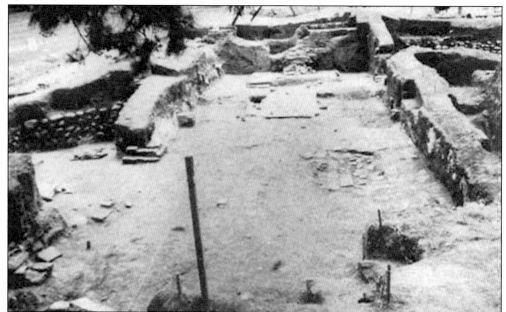

CHAPEL EXCAVATION AT THE PRESIDIO. In the 1960s and 1970s, San Diego State College Prof. Paul Ezell led archaeological excavations that located the Presidio's chapel, pictured here, and uncovered dozens of burials. The dig also pinpointed different activity areas within the chapel, such as the sanctuary, sacristy, and baptistry. (Courtesy SCIC.)

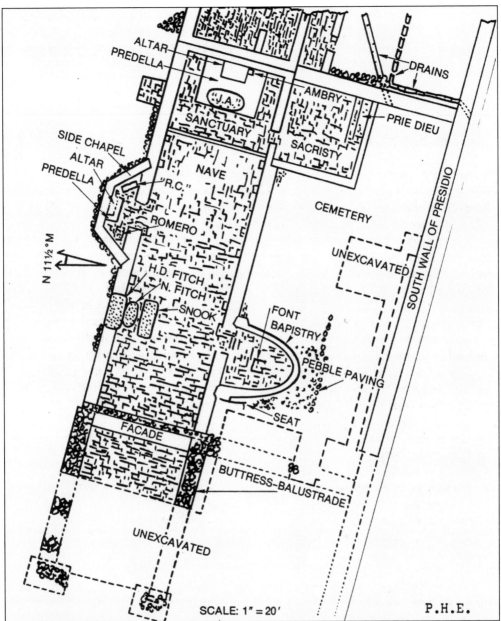

MAP OF ARCHAEOLOGICAL EXCAVATIONS AT THE PRESIDIO. The extrapolated chapel layout shown here is corroborated by various historical records. In 1792, Father-Presidente Lasuen, successor to Father Serra, discussed burial practices used by those in the California mission system, noting, "The settlers usually take the dead for burial to the nearest mission cemetery. Those of the [San Diego] presidio sometimes do likewise, but on other occasions they bury the dead in the presidio churches. The cemetery of the presidio of San Diego is situated on one side of the church, which is not the case at other presidios." Settlers continued to be buried in the Presidio Hill cemetery into the mid-1800s. (Courtesy SCIC.)

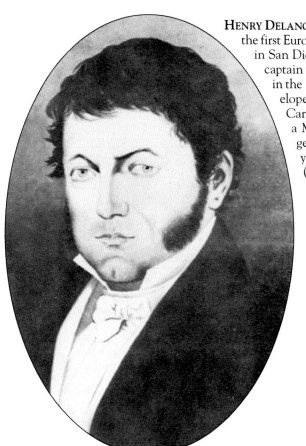

HENRY DELANO FITCH. Henry Fitch (1799–1849) was the first European-American to settle permanently in San Diego's Old Town. A Massachusetts sea captain who traded along the California coast in the 1800s, Fitch converted to Catholicism, eloped with a teenaged Spaniard (Joséfa Carrillo) on a ship to Chile, and became a Mexican citizen. Fitch ran the only general store in Old Town for many years and was the city's first attorney. (Courtesy SCIC.)

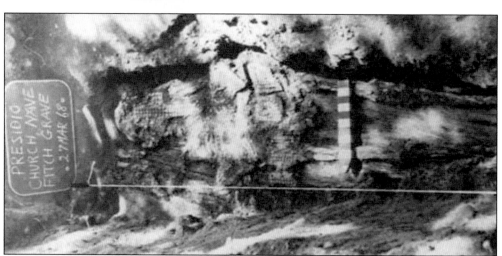

HENRY DELANO FITCH REMAINS. One of Professor Ezell's students uncovered the physical remains of Henry Delano Fitch under the former chapel's buried tile floor on Presidio Hill. Positive identification was made on the basis of the age and sex of the skeleton, the type of burial, and the presence of copper tacks on the surface of the coffin that formed a cross, two hearts, and the initials "H. D. F." (Courtesy SCIC.)

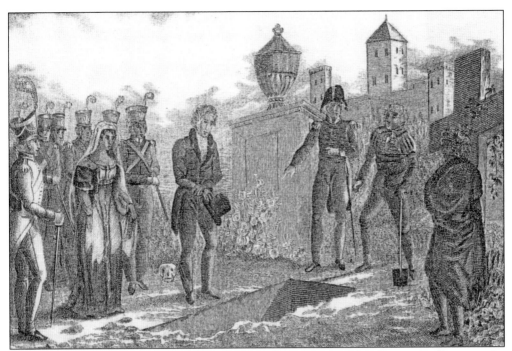

SAN DIEGO PRESIDIO. This 19th-century image depicts James Ohio Pattie standing over the grave of his father, Sylvester, who died in captivity in 1828 and was buried on Presidio Hill. The Patties were trappers, imprisoned by the Spanish upon their arrival in San Diego. Judging from the enormous medieval castle and Napoleonic Era uniforms, the artist had never visited an adobe fort on the California frontier. (Courtesy SCIC.)

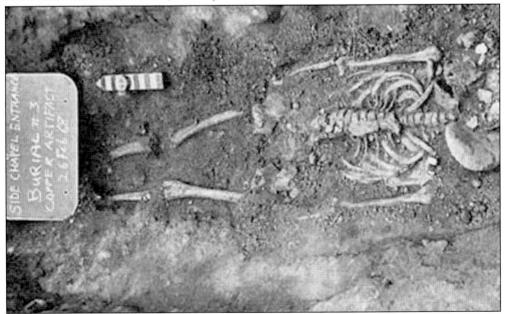

SAN DIEGO PRESIDIO BURIAL. This skeleton is believed to be that of a Presidio-era sailor, unearthed during Professor Ezell's archaeological excavations. Uncovered in February of 1968, this burial was located at the chapel's side entrance of the Presidio. (Courtesy SCIC).

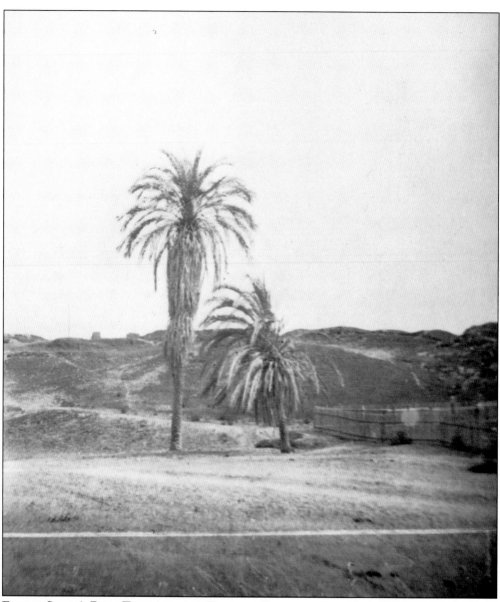

FATHER SERRA'S PALM TREES AND THE PRESIDIO CEMETERY. Spanish and Mexican settlers used Presidio Hill's burial grounds through the late 1700s and early 1800s. The cemetery was originally known as "El Jardin del Rey" (King's Garden) and later named the "Franciscan Gardens." When San Diegans began burying their dead in El Campo Santo in 1849 (see Chapter Two), Presidio Hill's cemetery became obsolete and fell into disuse. This image, taken in the late 1800s, is the only known contemporary photograph of the Presidio Cemetery. It shows the remains of the Presidio walls on the hilltop behind Father Serra's famed palm trees and the fenced cemetery to the right. (Courtesy SDHS.)

CLOSE-UP OF "DEAD MEN'S POINT."
"P. de los Muertos" is a name that first appears on Pantoja's 1782 map. Historical records describe an 18th-century Spanish squadron that anchored very close to the present site of downtown San Diego and surveyed the bay. Several sailors and soldiers died there and were interred on a sand spit. The exact location of their burials is unknown. Modern projections place the graveyard near the end of today's Market Street. (Courtesy SCIC.)

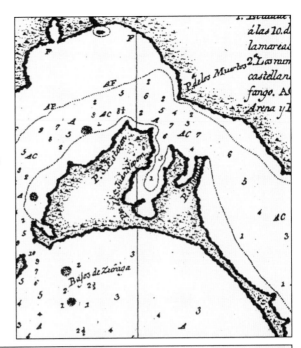

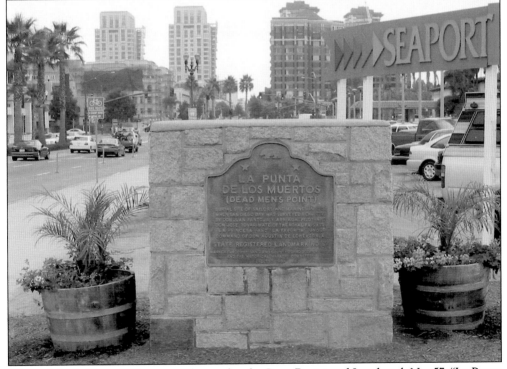

"DEAD MEN'S POINT" PLAQUE. The marker for State Registered Landmark No. 57, "La Punta de los Muertos," is at the intersection of Pacific Highway and Harbor Drive. It reads, "Burial site of sailors and marines in 1782 when San Diego Bay was surveyed & charted by Don Juan Pantoja y Arriaga, Pilot, and Don Jose Tovar, Mate, of the royal frigates 'La Princesa' and 'La Favorita' under command of Don Agustin de Echeverria." (Courtesy SCIC.)

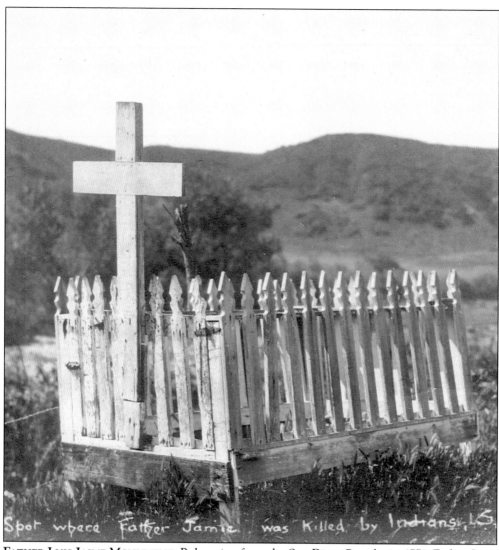

Spot where Father Jamie was killed by Indians. LS.

FATHER LUIS JAIME MONUMENT. Relocating from the San Diego Presidio in 1774, Father Serra established Mission San Diego de Alcalá near the California Native American village of *Nipaguay*. Mission San Diego de Alcalá was the first of 21 missions in Alta California. In 1775, local natives set fire to the mission, killing Father Luis Jaime and two neophytes. A painted cross and picket fence, characteristic of Catholic cemeteries of the period, marked the place where the padre fell. Father Jaime's remains are located within the chapel. The date of this photograph is unknown. (Courtesy SDSUSC.)

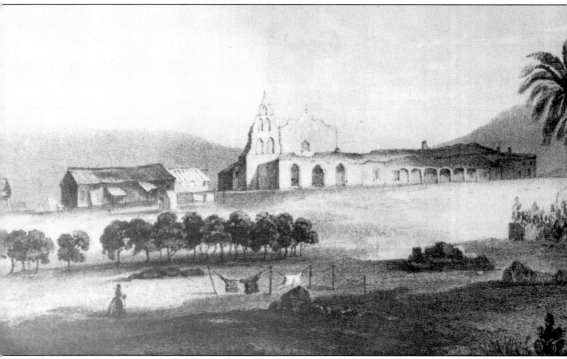

MISSION SAN DIEGO DE ALCALÁ PAINTING. Over a 200-year period, local clerics reconstructed Mission San Diego de Alcalá four times. The consecrated ground of the Spanish cemetery was to the east, at the right of the 1853 illustration pictured above. The mission was used intermittently as a barracks by American soldiers between 1847 and 1862. As the Visiting Committee of the State Agricultural Society noted in 1858, "The soldiers' graveyard, in immediate proximity to the barracks, is a place of melancholy interest. The number which is annually added to its tenantry . . . is truly surprising." (Courtesy SCIC.)

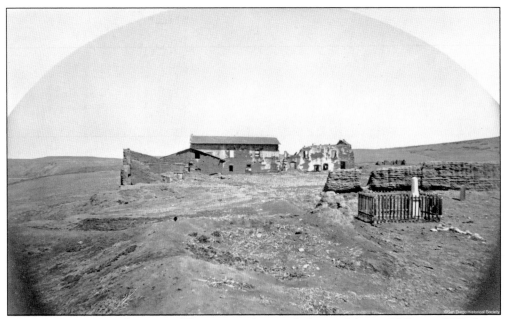

MISSION, LATE 19TH CENTURY. This westward view of a barren Mission Valley, *c.* 1876, shows the ruins and courtyard of Mission San Diego de Alcalá. In 1873, the *San Diego Union* reported, "East of this [mission] courtyard is the ancient cemetery. It contains but one lonely monument of marble. . . . There are eight headboards in other portions of the cemetery." The marble spire marks the grave of Sgt. Richard Kerren. (Courtesy SDHS.)

RICHARD KERREN MONUMENT. U.S. Army Sgt. Richard Kerren (1814–1856) was killed when he was thrown from his horse while returning to his barracks at Mission San Diego de Alcalá. The sergeant's gravestone was transferred along with his remains from Mission San Diego de Alcalá to the Post Cemetery on Point Loma, now Fort Rosecrans National Cemetery, about 1887. (Courtesy SCIC.)

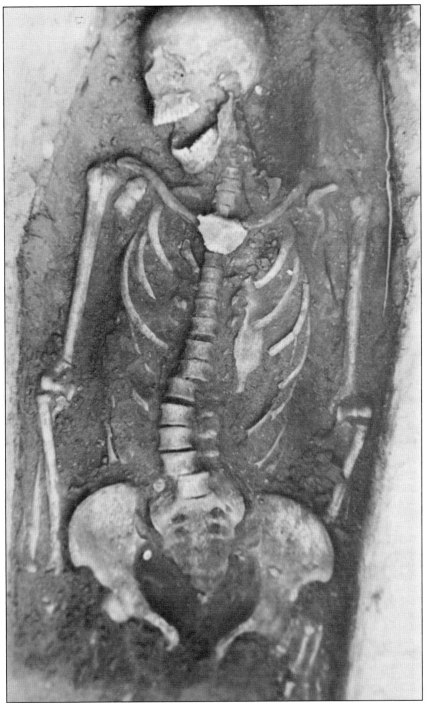

Nineteenth-Century U.S. Soldier Burial. A 1970 archaeological excavation conducted by Dr. James Moriarty of the University of San Diego uncovered the graves of U.S. soldiers within the chapel complex of Mission San Diego de Alcalá. This photograph shows the skeletal remains within one of those graves. The edges of the hexagonal coffin are well defined, and the trouser buttons can be seen on and around the pelvis. (Courtesy SCIC.)

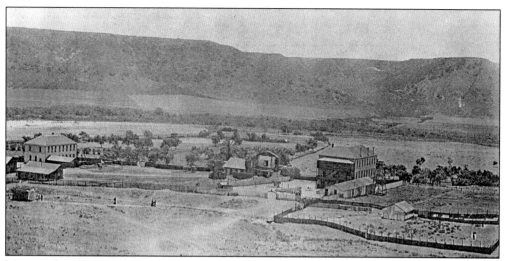

MISSION SAN DIEGO DE ALCALÁ, 1894. Development in the vicinity of Mission San Diego de Alcalá has covered or destroyed thousands of graves. Mission records indicate there were 4,332 deaths between 1769 and 1832, a number that includes both Spanish Catholics and Mexican and Indian converts but does not account for the later graves of U.S. soldiers or remains from the region's prehistoric indigenous population. (Courtesy SDHS.)

TODAY'S MISSION. In the 1980s, the church proposed building a recreation hall near the east compound of the old mission. Despite protests by historians, church lawyers convinced city officials to allow private contractors to excavate the area. The local media reported on the many skeletons exposed by the coring, which created enough of a public uproar to convince the church to fill the holes, change their building plans, and rededicate the area as a cemetery. (Courtesy SCIC.)

SAN PASQUAL CHAPEL, C. 1895. San Pasqual Chapel and its cemetery date from the time of the Pueblo of San Pasqual, established in 1835. During this time of mission secularization and forced Native American redistribution, the Mexican government awarded a large section of San Pasqual Valley to the San Pasqual Indians. In 1883, Father Ubach wrote of the dilapidated pueblo, "Whisky [sic] and brutal force; nothing but the cemetery and chapel left." (Courtesy Escondido History Center [EHC].)

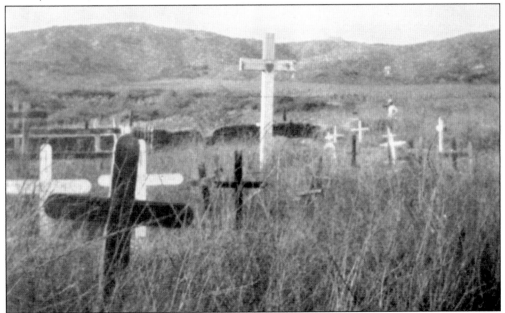

SAN PASQUAL INDIAN CEMETERY. Characteristic of Native American cemeteries throughout San Diego County, the San Pasqual Indian Cemetery was laid out in the Spanish-mission tradition. Burials were crowded within a compact area of consecrated ground and marked with wooden crosses; a larger cross was placed in a central location, in this instance decorated with a painted heart. The remains of the adobe chapel can be seen in the background. (Courtesy SCIC.)

FELICITA MORALES, DAUGHTER OF CHIEF PANTO. Felicita is a local legend. Her father, Kumeyaay chief Panto ("Capitan of San Pascual Pueblo"), aided the Americans at the Battle of San Pasqual. Felicita was an eyewitness to the battle and allegedly married one of the wounded Californios. In reality, she married "Boley" Morales. Felicita died in 1916 and is believed to be buried in the San Pasqual Indian Cemetery. (Courtesy EHC.)

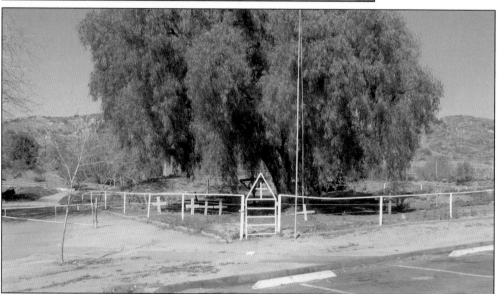

TODAY'S SAN PASQUAL INDIAN CEMETERY. The San Pasqual Indian Cemetery still exists and is located on what was once the campus of San Pasqual Union School. Situated along Highway 78, the area is now home to the San Diego Archaeological Center. The San Pasqual Indian Cemetery is owned by the San Pasqual Band of Mission Indians. Evidence of the chapel no longer exists. (Courtesy SCIC.)

Two

PIONEER CEMETERIES

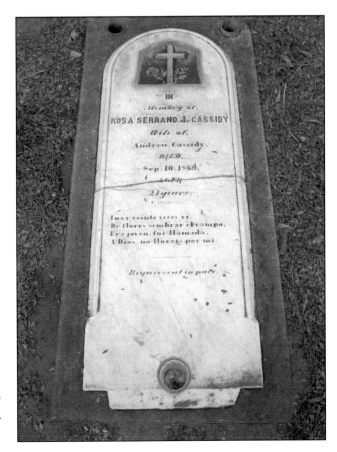

ROSA SERRANO DE CASSIDY
MONUMENT. The gravestone
of Rosa Serrano de Cassidy,
who died in 1869, is the earliest
original marker in El Campo
Santo. It is also the oldest dated
San Diego gravestone in, or at
least near, its original context.
The stone fractured in the early
1900s. When her grave was
refurbished in 1985 as part of
a restoration project, the stone
was placed flat in cement as a
protective measure. Serrano was
the first wife of Andrew Cassidy,
a San Diego administrator and
politician. She died at the age of
21. (Courtesy SCIC.)

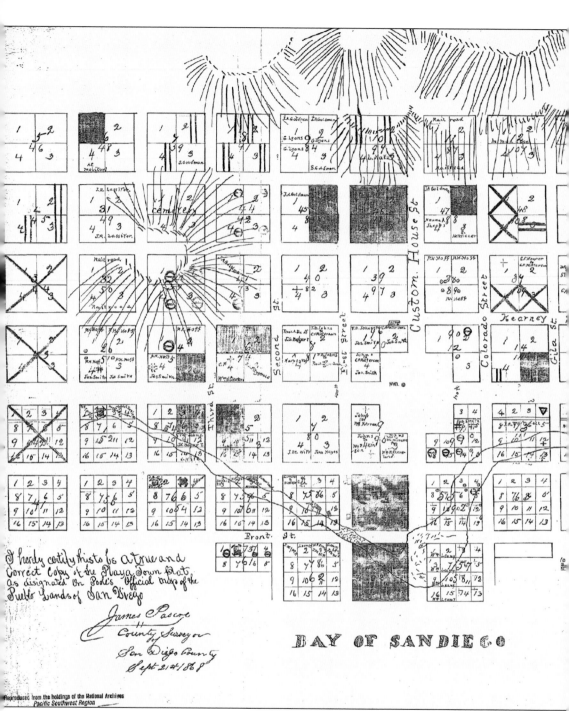

LA PLAYA TOWN MAP. This 1868 subdivision map pinpoints the La Playa Cemetery. However, by 1887, it was all but forgotten. The *San Diego Union* reported on September 20, 1887, "In a little plot of ground at the base of Point Loma and within a few hundred yards of the town of La Playa are four or five neglected graves. . . . Save for a fast-decaying headboard over one of the mounds,

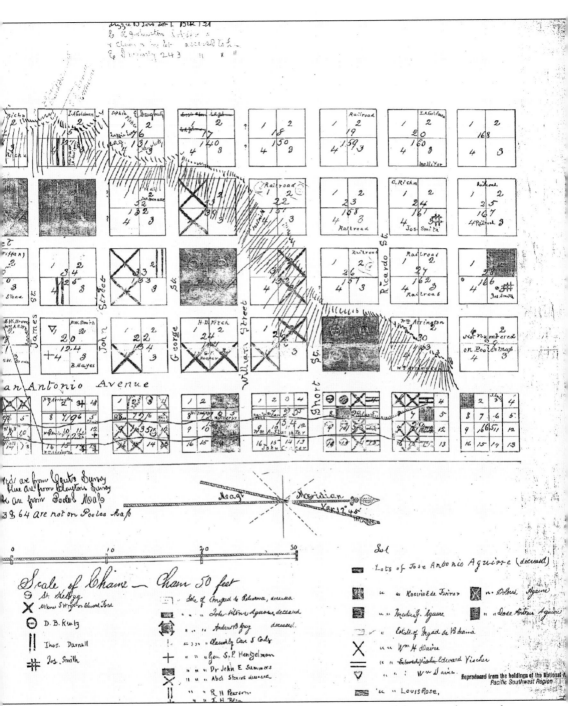

there is nothing to show who or what the men were that found a peaceful resting place on the shores of the Pacific Ocean." In the top left corner of this map (in the third column and second row of the subdivision), the word "cemetery" marks the location of the La Playa burial ground. It is slightly obscured by the map's hand-drawn topographic lines. (Courtesy SDHS.)

La Playa Cemetery Location. In the 1830s, Richard Henry Dana described La Playa, "There was no town in sight, (it being several miles from the harbour), but on the smooth sand beach, abreast, and within a cable's length of which three vessels lay moored, were four large houses, built of rough boards . . . with piles of hides standing round them." La Playa, located on the east side of Point Loma, was San Diego's first port and home to the area's only non-Spanish Catholic cemetery. In the image above, the arrow points to the cemetery's location on this 1907 subdivision map. (Courtesy SCIC.)

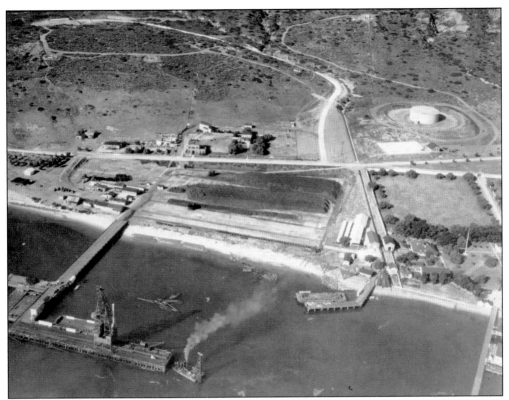

LA PLAYA AERIAL VIEW. The La Playa Cemetery was located on the hillside toward the center of this c. 1928 aerial photograph of the U.S. Navy coal docks. During construction in 1949, a crew operating a trenching machine inadvertently ripped the head ends from two caskets, which were under the asphalt road. (Courtesy SDHS.)

TODAY'S LA PLAYA CEMETERY. This image shows the view from the unmarked La Playa Cemetery as it appears today within the U.S. Navy submarine base. Although no grave markers remain, the identities of several individuals buried at La Playa are known. They include Seaman Neil McMullin, Capt. B. H. Burriel, several Russians who shipwrecked on North Island, Pvt. Albert Dunham, and Lydia Hunter. Dunham and Hunter were reburied in Fort Rosecrans (Post Cemetery) in 1887. (Courtesy SCIC.)

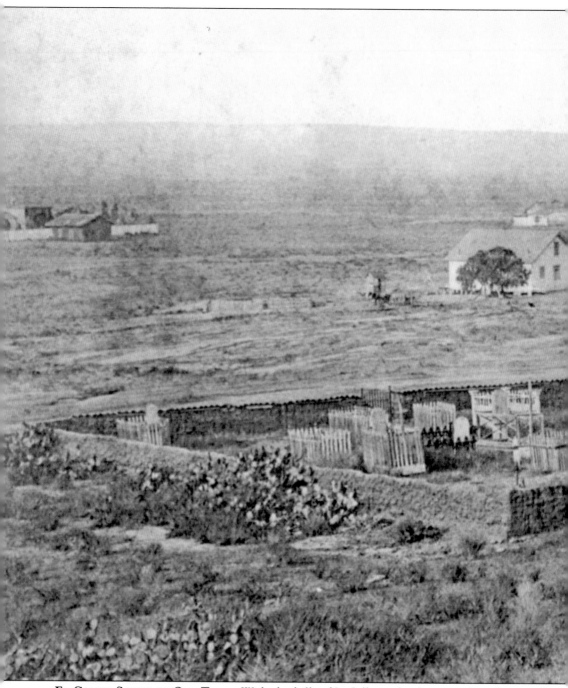

EL CAMPO SANTO IN OLD TOWN. With the hills of La Jolla in the distance, this photograph of San Diego's Old Town in the 1880s shows El Campo Santo, the city's Catholic cemetery, surrounded by an adobe wall. The picket fencing around the individual graves was a common practice of the Spanish Catholic tradition. Just off center, surrounded by distinctive black iron

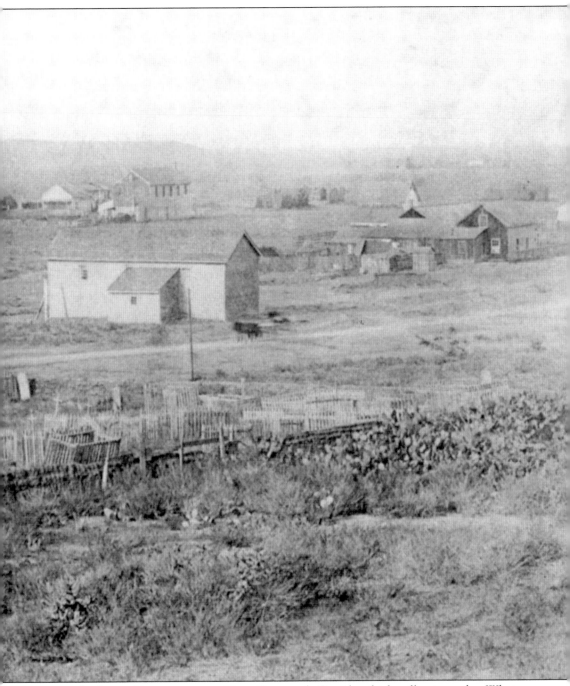

fencing, is the large white gravestone of Rosa Serrano de Cassidy, which still exists today. What remains of El Campo Santo is located in the heart of today's Old Town along San Diego Avenue. (Courtesy SCIC.)

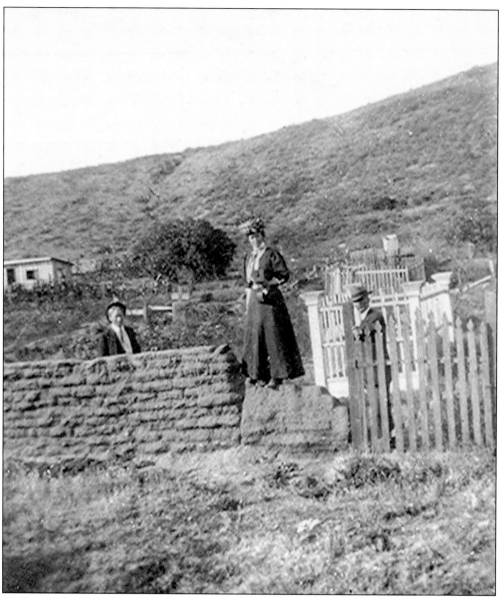

EL CAMPO SANTO'S ORIGINAL GATE. As the Presidio fell into disrepair and was no longer used, Old Town's *El Campo Santo* ("The Holy Field") became the local cemetery for San Diego's Catholic population. Following its first recorded burial in 1849, at least 476 more individuals were interred at El Campo Santo by the end of the 1880s. The trio posing by the original gate of El Campo Santo about 1910 is facing what is now San Diego Avenue. (Courtesy SDSUSC.)

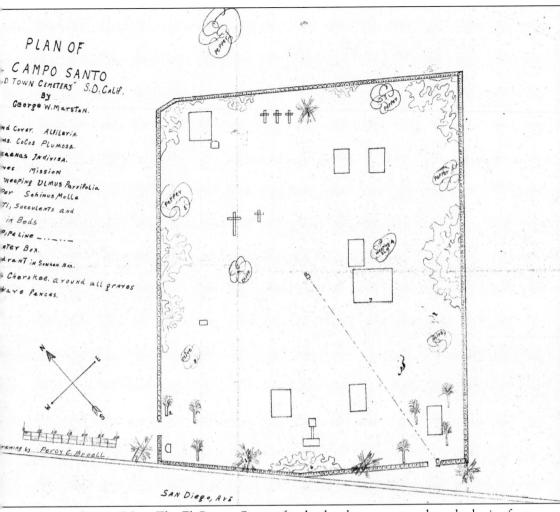

PLAN OF
CAMPO SANTO
D TOWN CEMETERY" S.D.CALIF.
BY
George W. Marston.

nd Cover. Altileria.
ms. Cocos Plumosa.
caenas Indivisa.
ves Mission
weeping Ulmus Parrifolia
Der Schinus Molle
Ti, Succulents and
in Beds
Pipe Line ___.___
ater Box.
drant in Sunken Box.
Cherokee. around all graves
have Fences.

ewing by Percy C. Broell

SAN Diego, Ave

EL CAMPO SANTO MAP. The El Campo Santo of today has been re-created on the basis of historical photographs and documentation. Some bodies were relocated in the 1870s, and then in 1894, a street railway bisected the cemetery. George Marston's map of El Campo Santo, believed to have been commissioned in the 1920s, shows the outline of a smaller cemetery with the lower left corner missing, probably as a result of the railway. The gate has been moved from the middle of the wall to the lower right corner. (Courtesy SDHS.)

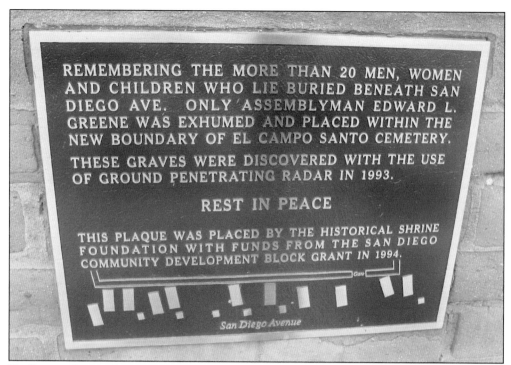

REMEMBERING THE MORE THAN 20 MEN, WOMEN
AND CHILDREN WHO LIE BURIED BENEATH SAN
DIEGO AVE. ONLY ASSEMBLYMAN EDWARD L.
GREENE WAS EXHUMED AND PLACED WITHIN THE
NEW BOUNDARY OF EL CAMPO SANTO CEMETERY.

THESE GRAVES WERE DISCOVERED WITH THE USE
OF GROUND PENETRATING RADAR IN 1993.

REST IN PEACE

THIS PLAQUE WAS PLACED BY THE HISTORICAL SHRINE
FOUNDATION WITH FUNDS FROM THE SAN DIEGO
COMMUNITY DEVELOPMENT BLOCK GRANT IN 1994.

San Diego Avenue

EL CAMPO SANTO PLAQUE. Most pedestrians and drivers are oblivious to the more than 20 individuals buried under San Diego Avenue in front of El Campo Santo. The graves were located by ground-penetrating radar in 1993. At least another 13 burials are under Linwood Street behind the cemetery. (Courtesy SCIC.)

ANONYMOUS GRAVE MARKER. A small medallion, no more than a few inches in diameter, marks the grave of an unknown citizen under the sidewalk in front of El Campo Santo. (Courtesy SCIC.)

ANTONIO GARRA BURIAL SITE. Garra (?–1852) was a Cupeño Indian leader who lived in northern San Diego County in the early 19th century. After witnessing rampant Anglo-American taxation without representation by San Diego's inaugural sheriff Agoston Haraszthy, Garra organized a revolt among different southern California tribes against the United States. The 1851–1852 Garra Revolt resulted in nine casualties and substantial property damage at Warner's Ranch and ended with the capture of its indigenous leaders. (Courtesy SCIC.)

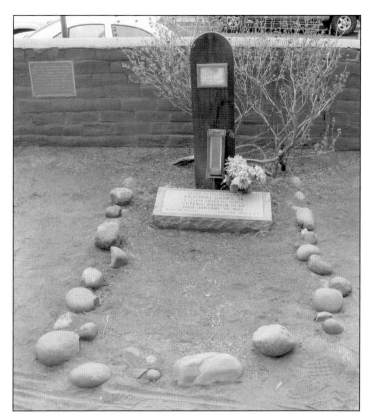

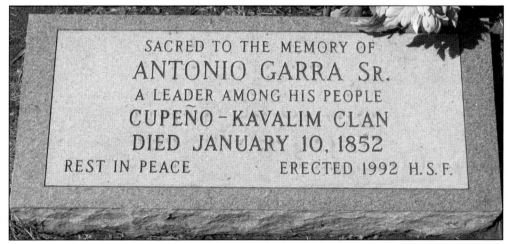

ANTONIO GARRA MONUMENT. After being found guilty of treason, Garra faced a firing squad. At the execution, Father Holbein commanded that Garra beg forgiveness of the gathered crowd. Garra, who purportedly had already corrected the priest's faulty Latin during his final rites (Garra spoke five Indian dialects as well as Latin), initially refused. Finally, after repeated admonishments, he slyly told his audience, "Gentlemen, I ask your pardon for all my offenses, and expect yours in return." (Courtesy SCIC.)

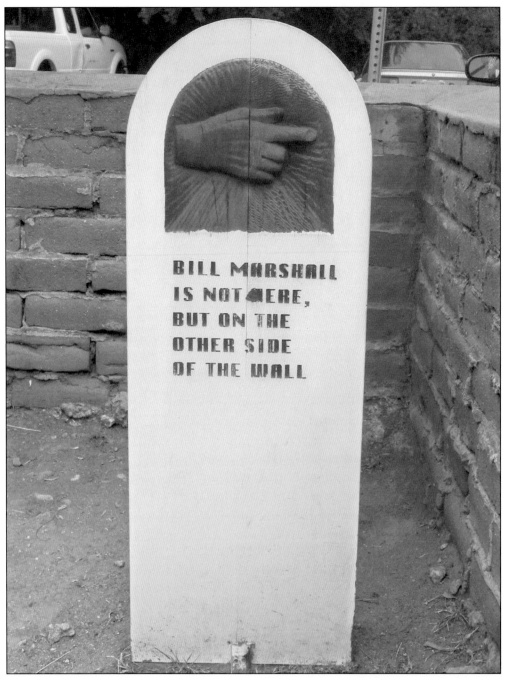

WILLIAM MARSHALL SUBSTITUTE MONUMENT. Deemed the "wickedest man in California," William Marshall (1827–1851) was hanged for his participation in the Garra Revolt. He was also implicated in the 1846 Pauma Massacre, which killed 11 Anglo-Americans. Although Marshall claimed that Garra forced Juan Verdugo and himself to join the revolt and that they intended to abandon the California Native Americans at their first opportunity, the presiding Fitzgerald Volunteers at the court martial found Marshall and Verdugo guilty of high treason and executed them. (Courtesy SCIC.)

JAMES "YANKEE JIM" ROBINSON GRAVESITE AND MONUMENT. Hanged for stealing the schooner *Plutus*, Yankee Jim (?–1852) was a French-Canadian outlaw and horse thief. He was charged with theft of the $6,500 boat along with accomplices James A. Loring and William Harney. Although Loring and Harney received minimal one-year prison terms, Yankee Jim was sentenced to hang from a crude cross-bar gallows hastily built by the U.S. Army during the 1852 Garra Revolt. (Courtesy SCIC.)

YANKEE JIM AND THE WHALEY HOUSE. The six-foot-four-inch convict was too tall for the gallows; his toes touched the ground during the hanging. As a result, Yankee Jim slowly suffocated. Thomas Whaley, the man who would later purchase the land and build a home on which the hanging took place, witnessed the execution (see page 69). Whaley House visitors have reported feeling a choking sensation when passing up the stairs that stand near where Yankee Jim was hanged. (Courtesy SCIC.)

SHERIFF'S OFFICE,

SAN DIEGO COUNTY.

———————

To *D. V. Millard.*

You are invited to be present at the

Execution of

FELISARIO ALIPAS

On Friday Afternoon, July 2d, 1875,

Between the hours of 2 and 4 o'clock.

N. Hunsaker

Sheriff.

FELISARIO ALIPAS EXECUTION INVITATION. Justice in 19th-century San Diego was brutal and swift. However, what it lacked in compassion, it made up in decorum. This invitation was to the execution of Felisario Alipas, a California Native American condemned for the murder of an Anglo-American citizen. He received a temporary stay but was eventually executed on September 3, 1875, and buried in El Campo Santo. (Courtesy SCIC.)

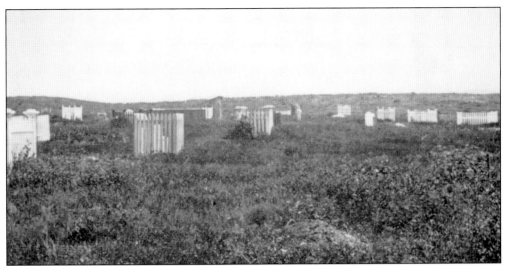

PROTESTANT CEMETERY, C. 1874. Burials began in the Protestant Cemetery around 1850 and continued at least until 1869, the year Mount Hope Cemetery (see chapter three) was established. The Protestant Cemetery then slowly began to deteriorate. As the weeds overgrew the rotting wooden grave markers, the cemetery was used variously as a dog pound, goat farm, and dump. (Courtesy SDHS.)

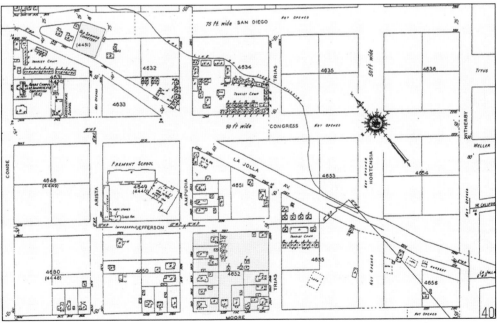

SANBORN MAP WITH PROTESTANT CEMETERY ALREADY GONE, C. 1920. The Protestant Cemetery, colloquially known as the Masonic, American, or General Cemetery, was located in Old Town on Ampudia Street, between Moore and Jefferson Streets. A separate section, known as the San Pasqual Gravesite, extended farther to the southwest. Apathy and rampant development from the 1870s onward, including the bisection of the cemetery by Trias Street (now Old Town Avenue), gradually erased the burial ground. (Courtesy SCIC.)

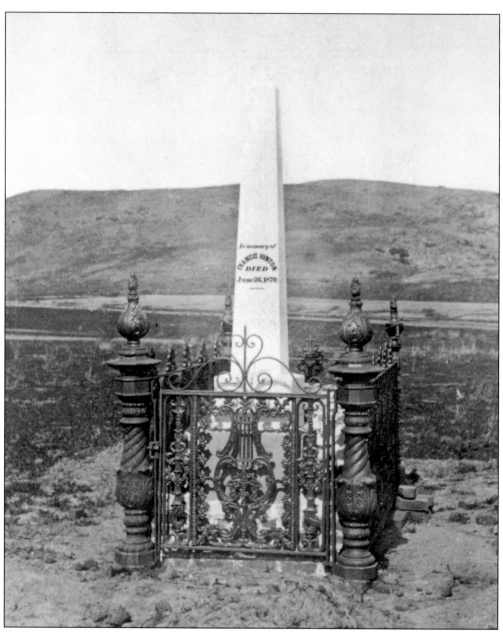

FRANCIS HINTON MONUMENT. The gravestone of Francis "Jack" Hinton (1818–1870) was impressive for its time. A New Yorker, born Abraham Ten Eyck DeWitt Hornbeck, Hinton was a Mexican War veteran, miner, and merchant who prospered both in Yuma, Arizona, and in San Diego. In 1865, he purchased the enormous Rancho Agua Hedionda in the Carlsbad area. Buried initially in the Protestant Cemetery, Hinton was eventually exhumed and moved to Mount Hope Cemetery. This photograph of Hinton's marker in the Protestant Cemetery was taken about 1874. (Courtesy SDHS.)

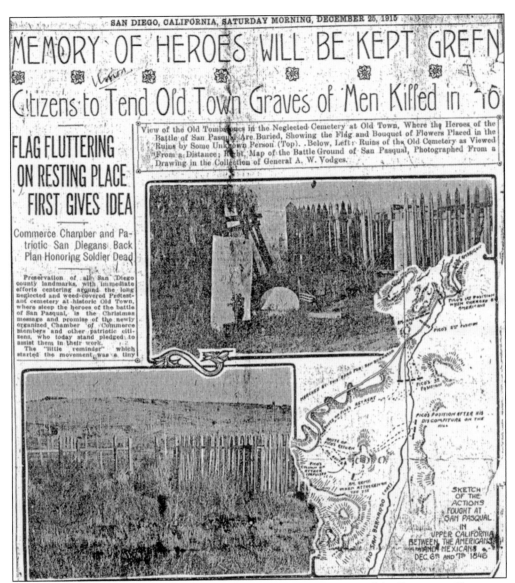

SAN DIEGO, CALIFORNIA, SATURDAY MORNING, DECEMBER 25, 1915

MEMORY OF HEROES WILL BE KEPT GREEN

Citizens to Tend Old Town Graves of Men Killed in '16

FLAG FLUTTERING ON RESTING PLACE FIRST GIVES IDEA

Commerce Chamber and Patriotic San Diegans Back Plan Honoring Soldier Dead

Preservation of all San Diego county landmarks, with immediate efforts centering around the long neglected and weed-covered Protestant cemetery at historic Old Town, where sleep the heroes of the battle of San Pasqual, is the Christmas message and promise of the newly organized Chamber of Commerce members and other patriotic citizens, who today stand pledged to assist them in their work.

The "little reminder" which started the movement, was a tiny

View of the Old Tombstones in the Neglected Cemetery at Old Town, Where the Heroes of the Battle of San Pasqual Are Buried, Showing the Flag and Bouquet of Flowers Placed in the Ruins by Some Unknown Person (Top). Below, Left: Ruins of the Old Cemetery as Viewed From a Distance; Right, Map of the Battle Ground of San Pasqual, Photographed From a Drawing in the Collection of General A. W. Vodges.

PROTESTANT CEMETERY NEWSPAPER ARTICLE. A separate section of the Protestant Cemetery, the "Government Graveyard" or "San Pasqual Graveyard," was reserved for those individuals who died during the Battle of San Pasqual in 1846. Their bodies were exhumed from the battlefield and moved to the San Pasqual Graveyard section of the Protestant Cemetery in 1848. The patriotic 1915 article, pictured here, appears to honor the fallen heroes. In reality, however, it was a promotional gimmick to garner support for the preservation of Old Town. The soldiers' bodies had been removed 41 years previously. (Courtesy *San Diego Union*, December 25, 1915.)

W. W. WARE MONUMENT AND UNKNOWN MONUMENT. The top image, taken in 1915, shows the grave of W. W. Ware (1822–1860), a mason and member of the Board of Supervisors in 1860. An American flag was placed by his grave under the mistaken assumption that he was a San Pasqual veteran. The bottom image, also dating to 1915, is of an unknown grave. By the time these photographs were taken, there was little left of the Protestant Cemetery; the bodies had either been exhumed or forgotten. A sewer project in the 1930s uncovered the remains of at least five human burials, in addition to multiple brass uniform buttons. (Both courtesy SDHS.)

ORIGINAL JEWISH CEMETERY SITE. Just off Midway Drive, Sharp Cabrillo Hospital stands over what was once San Diego's first Jewish cemetery, a five-acre plot in the 2900 block of Fordham Street in the neighborhood of Roseville. Louis Rose, a Jewish immigrant and entrepreneur who founded Roseville, donated the land in 1862. The burial ground was used until Congregation Beth Israel established the Jewish section of Mount Hope Cemetery in 1892. (Courtesy SCIC.)

JEWISH CEMETERY. The only known image of San Diego's original Jewish Cemetery, this photograph was taken in the 1930s, just prior to the exhumation and transfer of bodies to Home of Peace Cemetery. It shows the gravestone of Bertha Barnett. The land was leased to the federal government for the Frontier Homes Housing Project during World War II. (Courtesy SCIC.)

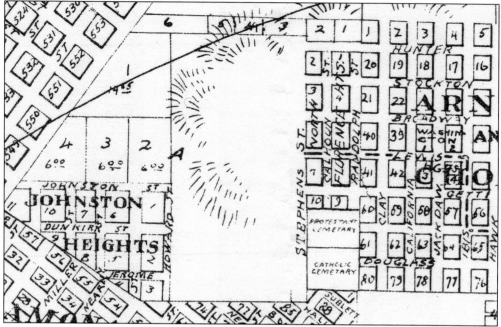

CALVARY CEMETERY MAP. This 1907 subdivision map shows both a Protestant and a Catholic cemetery in Mission Hills. In the 1870s, Joseph Mannasse sold 10 acres to the City of San Diego for a cemetery, with 5 acres for each of the two faiths. Although the Protestants never used their land, the Catholics established a new burial ground to replace El Campo Santo. Father Ubach laid out this graveyard, named Calvary Cemetery. (Courtesy SCIC.)

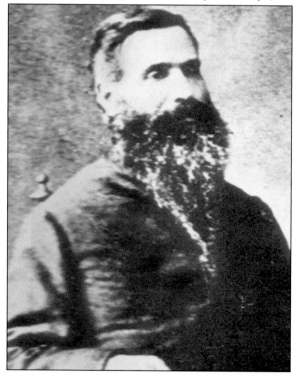

FATHER ANTONIO UBACH. A Catalonia native, Father Ubach (?–1907) came to San Diego in 1866 after traveling thousands of miles as a missionary among various Native American tribes. A charismatic character who received special dispensation to wear a beard and often brought a football to morning services for post-sermon play with the congregation's children, Father Ubach was known as "the last of the Padres." (Courtesy SCIC.)

NINETEENTH-CENTURY CALVARY CEMETERY. No one knows exactly how many individuals are buried in Calvary Cemetery; estimates range from 1,650 to over 3,400. Among those interred are some of San Diego's earliest pioneers. This image is of Calvary Cemetery during the late 1800s; the mourner is kneeling at the grave of Clara B. Foley. (Courtesy SDHS.)

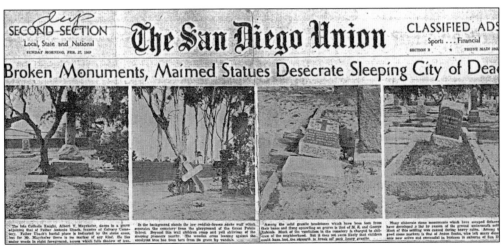

CALVARY CEMETERY'S DECLINE. Calvary Cemetery saw its greatest use during the influenza pandemic of 1918–1919. However, when the Catholic Church opened Holy Cross Cemetery in 1919, Calvary Cemetery became obsolete. Although a WPA project was instituted to rehabilitate the cemetery in the late 1930s and early 1940s, the graveyard fell into disrepair. Calvary Cemetery's last burial was in 1960. (Courtesy *San Diego Union*, February 27, 1949.)

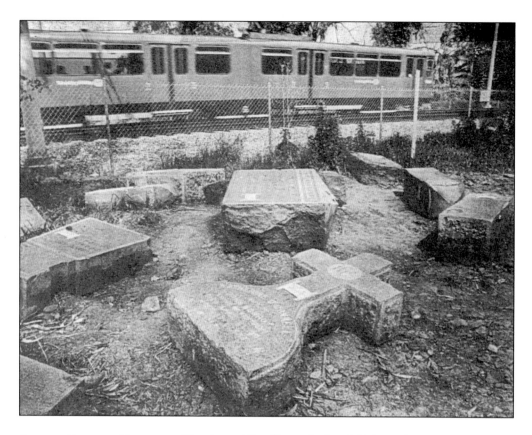

RAZING CALVARY CEMETERY. The City of San Diego declared Calvary Cemetery abandoned in 1968. A year later, all gravestones were razed and unceremoniously dumped in a ravine at Mount Hope Cemetery. Both images on this page show the destruction; the top photograph displays the discarded stones as the trolley passes by, and the bottom depicts a group from the Guy B. Woodward Museum searching for gravestones of the Ramona pioneers who were buried at Calvary Cemetery. It was the casually discarded grave markers at Mount Hope that caused public outrage. Most of the displaced gravestones were eventually buried in a mass grave at Mount Hope Cemetery. (Above courtesy *Los Angeles Times*, February 23, 1988; below courtesy *Ramona Sentinel*, April 23, 1987.)

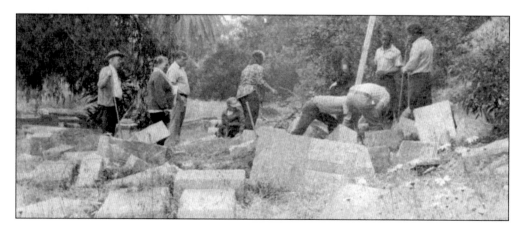

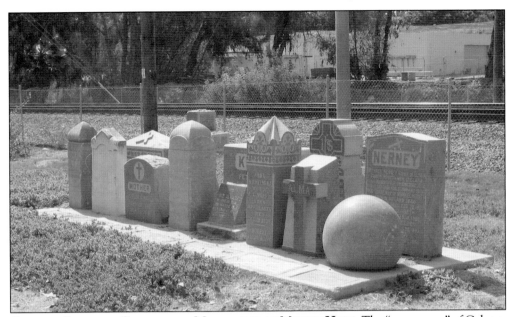

CALVARY CEMETERY GRAVESTONE MONUMENT AT MOUNT HOPE. The "mass grave" of Calvary Cemetery grave markers is today marked by this display of representative head stones. The authors of this book have been unable to find other examples of a mass grave for gravestones from any time period, region, or culture. (Courtesy SCIC.)

CALVARY CEMETERY GRAVESTONE MONUMENT AT PIONEER PARK. The only indication that Calvary Cemetery ever existed in Mission Hills is a memorial consisting of about 140 gravestones selected for their historical significance, set in cement at the southeastern corner of Pioneer Park. Six brass plaques list the known dead, with a smaller plaque reading, "Dedicated to the memory of those interred within this park." (Courtesy SCIC.)

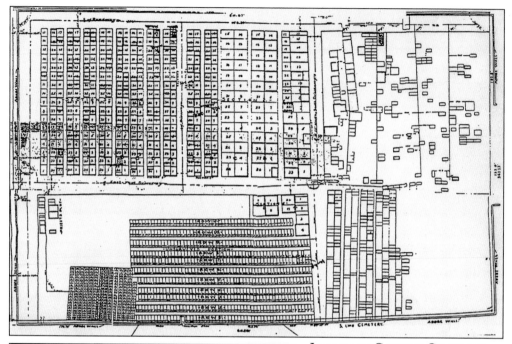

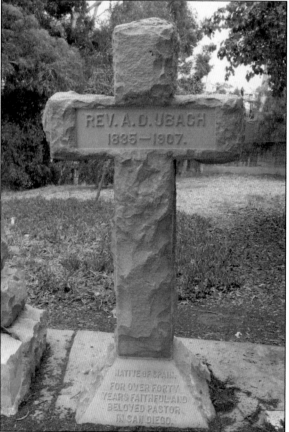

LEGACY OF CALVARY CEMETERY. Today's Pioneer Park is a striking example of San Diego's struggle with historic preservation in the face of rampant development. Few visitors strolling through today's Pioneer Park in the affluent Mission Hills district of San Diego realize that they are walking on the graves of several thousand individuals, as evidenced by this 1942 plot map of Calvary Cemetery. (Courtesy SCIC.)

FR. ANTONIO UBACH MONUMENT. How would Father Ubach have reacted if he had known that the razing of Calvary Cemetery was bolstered by an obscure 1957 city law? Would it make him—as the saying goes—roll over in his grave? If so, it must be remembered that he would be rolling in an unmarked grave. His exact burial location within Pioneer Park remains a mystery. (Courtesy SCIC.)

48

CAVE COUTS MONUMENT. One of Southern California's richest men, Cave Couts (1821–1874) had well-known relatives (his uncle was postmaster general under President Polk) and participated in notorious events (he was the judge-advocate at Garra's court martial, and later, Couts was dubiously acquitted of murdering Juan Mendoza). However, Couts's historical fame is due to his meticulousness; he recorded nearly every aspect of his life, producing 16,000 pages of diaries, notebooks, and letters. (Courtesy SCIC.)

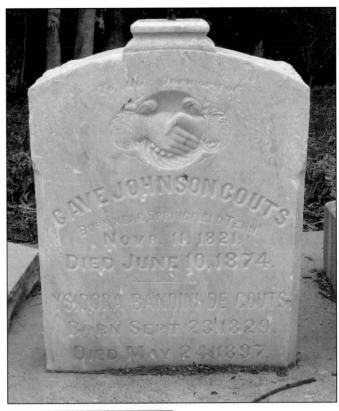

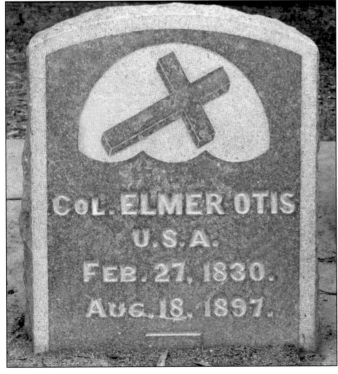

ELMER IGNATIUS OTIS MONUMENT. A military officer who saw extensive combat in the Civil War and Indian Wars, Elmer Ignatius Otis (1830–1897) gained fame for forcing elusive Indian chief "Captain Jack" to surrender during the Modoc War. Otis married Agnes Boone, the great-granddaughter of legendary pioneer and folk hero Daniel Boone, in 1861. (Courtesy SCIC.)

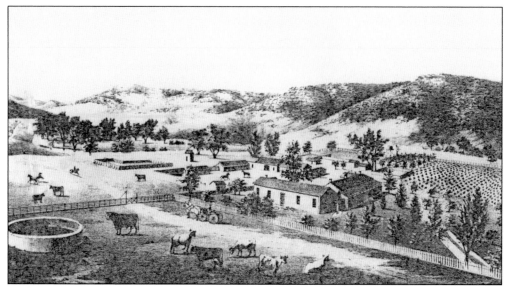

JOHNSON-TAYLOR ADOBE RANCH HOUSE LITHOGRAPH. George Alonzo Johnson established the Johnson-Taylor Adobe Ranch House on Rancho de los Peñasquitos in 1862. The original structure and later additions pictured in this c. 1883 image served over time as a residence, bunkhouse, and hotel. Rancho de los Peñasquitos was a working cattle ranch into the 1960s. (Courtesy San Diego County, Department of Parks and Recreation, History Archive.)

JOHN EICHER GRAVESITE. John Eicher (1825–1882) was a hired hand on Rancho de los Peñasquitos who died of consumption. His grave, located south of the Johnson Ranch compound in a small clearing, was originally outlined with cobbles and marked by a marble tablet. Vandalism reduced the site to a wooden post supporting a framed photograph of the gravestone. Today Eicher's pellet-marked gravestone is stored off-site for safekeeping. (Courtesy SCIC.)

LINDA VISTA CEMETERY. Located on MCAS Miramar at the eastern side of Highway 15, Linda Vista Cemetery is halfway up the hillside, directly in line with the runways, and can be glimpsed by drivers as they speed past. The small farming community of Linda Vista was established in the 1880s, with its small burial ground servicing the few inhabitants of Linda Vista, Miramar, and Sorrento Valley. (Courtesy SCIC.)

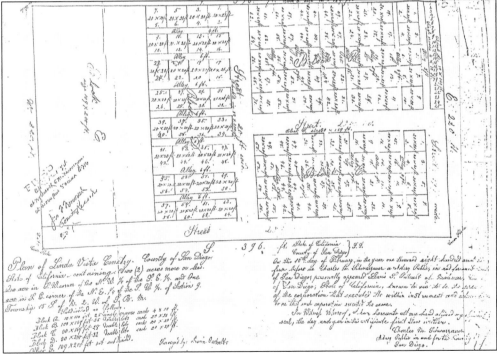

NINETEENTH-CENTURY LINDA VISTA CEMETERY PLOT MAP. Sam Porter, the original owner of the land, sold two acres to the Linda Vista Cemetery Association in 1893. The consequent subdivision into burial plots was overly optimistic, as it is believed no more than nine people were buried there. Interestingly the actual cemetery is approximately 200 feet north of the officially designated location. (Courtesy SCIC.)

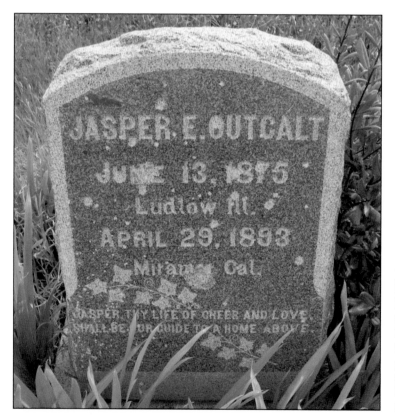

In Consideration of the sum of _Three_ Dollars, this day paid

THE LINDA VISTA CEMETERY ASSOCIATION

does hereby grant unto _C. M. Schwarzauer of Linda Vista, Cal._
and _his_ heirs and assigns forever, Block No. _B_ Lot No. _70_
in the Linda Vista Cemetery, San Diego County, State of California, according to the official plat thereof, to be used only for the burial of the human dead by said grantee, and in accordance with the by-laws of said grantor.

IN WITNESS WHEREOF, the said grantor has, by resolution of its Board of Trustees, caused these presents to be subscribed by its President and Secretary, and its corporate name and seal to be affixed hereto, this _nineteenth_ day of _April_ 189_4_

THE LINDA VISTA CEMETERY ASSOCIATION,

Attest _C. M. Schwarzauer._ SECRETARY. By _J. J. ____-t_ PRESIDENT.

LINDA VISTA CEMETERY ASSOCIATION PLOT RECEIPT. This receipt from April 19, 1894, reveals that the cost of a plot in Linda Vista was $3. (Courtesy SCIC.)

JASPER E. OUTCALT MONUMENT. Jasper E. Outcalt was the first person to be buried in Linda Vista Cemetery. His bullet-pocked gravestone survives (just barely) to this day. (Courtesy SCIC.)

SAINT JOHN'S LUTHERAN CHURCH CEMETERY THEN. Saint John's Lutheran Church was built in 1889 adjacent to Otay Mesa Road. A cemetery was subsequently established under the name of the German Lutheran St. John's Cemetery Association of Otay. Church activity declined after World War I, and the building was torn down around 1940. This is the only known photograph of the church; its date is unknown. (Courtesy Pacific Southwest District Archives of the Lutheran Church–Missouri Synod.)

SAINT JOHN'S LUTHERAN CHURCH CEMETERY NOW. The California Division of Highways became aware of the abandoned Saint John's Lutheran Church Cemetery in 1970 while planning a proposed "Route 75." They located and exhumed a number of bodies, which were then reinterred at Glenn Abbey Memorial Park in Bonita. As of early 2004, the site of the original church and cemetery was a graded field. Brown Field can be seen in the background. (Courtesy SCIC.)

MOUNT OLIVET CEMETERY. Located at the corner of Iris Avenue and Green Bay Street in the South San Diego neighborhood of Nestor, Mount Olivet Cemetery has been a local institution for over 100 years. Established as a private cemetery in 1899 by Hollis M. Peavey, the Mount Olivet Cemetery Association was incorporated by the Peavey family in 1954. The skills of the sign painter were questionable. (Courtesy SCIC.)

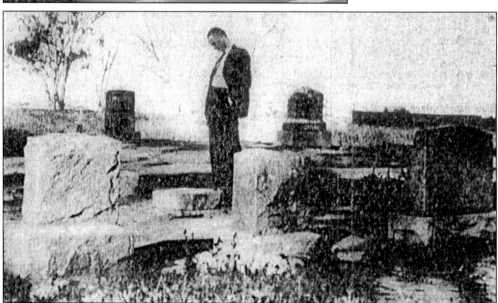

MOUNT OLIVET GRAVES. There are 314 burial plots within Mount Olivet Cemetery, with around 100 to 150 actual burials. An unknown number of people were illegally buried there in the 1920s. According to cemetery founder Hollis Peavey, fresh graves would appear overnight, although no one in town had died; individuals from neighboring areas were allegedly sneaking in and burying family members. By the time this photograph was taken in the 1960s, the cemetery had fallen into disrepair. (Courtesy *Star-News*, December 8, 1960.)

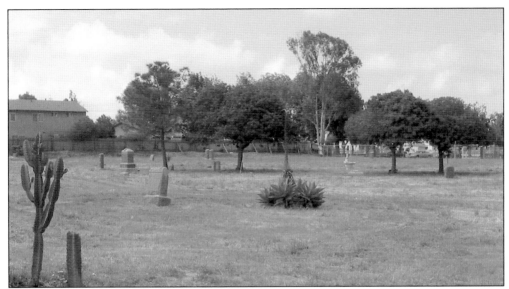

MOUNT OLIVET CEMETERY LAYOUT. Owned by the Mathias family since the 1980s, Mount Olivet Cemetery is currently inactive. The last burial was in 1998, although several plots are still owned by local residents. There are approximately 50 gravestones remaining, with dates spanning the 20th century. Some have been damaged by vandals. A number of Mount Olivet's gravestones form a circular pattern, an arrangement that is somewhat rare in San Diego. (Courtesy SCIC.)

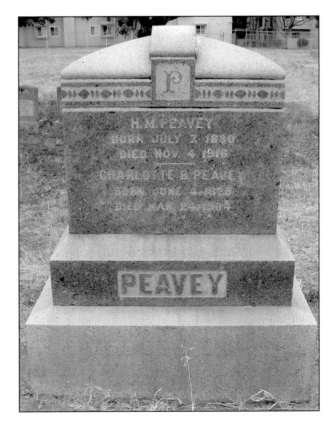

HOLLIS AND CHARLOTTE PEAVY MONUMENT. Mount Olivet Cemetery founder Hollis M. Peavey (1830–1916) and his wife, Charlotte B. Peavey (1828–1904), are fittingly interred in their own burial ground. (Courtesy SCIC.)

55

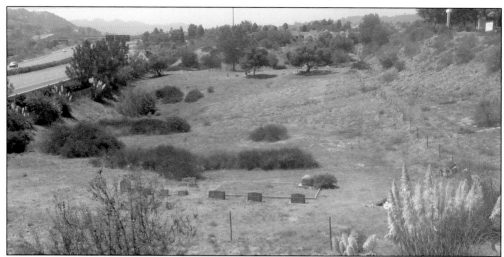

TODAY'S CARMEL VALLEY CEMETERY. The Sisters of Mercy, the religious order that established Mercy Hospital, arrived in San Diego in the 1890s. In exchange for health care, the McGonigle family gave the sisters 1,000 acres in Carmel Valley. The sisters established Carmel Valley Cemetery about 1900. Expansion of Carmel Valley Road (Highway 56) has left the cemetery below the level of the road surface, as is shown in this 2002 photograph. (Courtesy SCIC.)

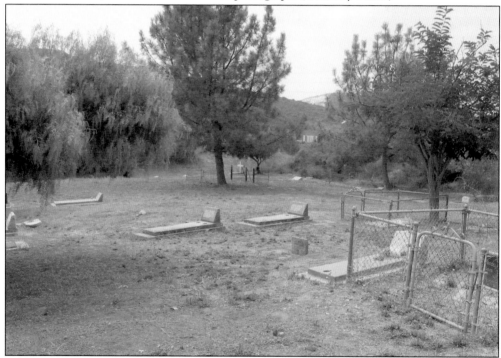

CATHOLIC SECTION OF CARMEL VALLEY CEMETERY. The cemetery has two sections; Catholics to the west and Protestants to the east. The Catholic section pictured here includes pioneers, parishioners, and several Sisters of Mercy. The Protestant section, shown in the foreground of the top photograph, contains many San Diego pioneers with well-known names like Knechtel, Sawyer, Standish, Nieman, McGonigle, and Switzer. Fire and vandalism have removed all grave markers prior to 1940. (Courtesy SCIC.)

ANTON KNECHTEL GRAVESITE. The Knechtel family was intricately involved in agricultural development within Carmel Valley, McGonigle Canyon, and Shaw Valley. The gravesite of San Diego pioneer Anton Knechtel (1823–1903) sits atop a ridge above Carmel Country Road with a sweeping view of Carmel Valley. It was a favored location from which Anton Knechtel would survey his home and land. (Courtesy SCIC.)

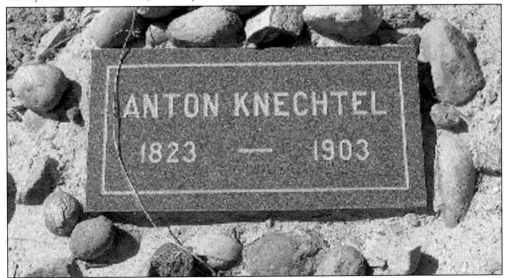

ANTON KNECHTEL MONUMENT. Although the first Knechtel home was in Shaw Valley, the land that is home to Knechtel's grave was originally acquired as a homestead by his daughter Mary. She later sold the property. The remote location of the gravesite has protected it from vandalism. The fence and gravestone are of relatively recent origin and significantly post-date Knechtel's 1903 passing. (Courtesy SCIC.)

HAMPE FAMILY CEMETERY. Christoph and Martha Hampe, along with their son Harry arrived in San Diego in 1906 and established a 161-acre farmstead west of Black Mountain Road, on which now stand Adobe Bluffs Elementary School, Adobe Bluffs Neighborhood Park, and numerous tract homes. The Hampe Family Cemetery was located just to the center of the photograph, on the hilltop to the right of the white building. (Courtesy Raymond Hampe Collection [RHC].)

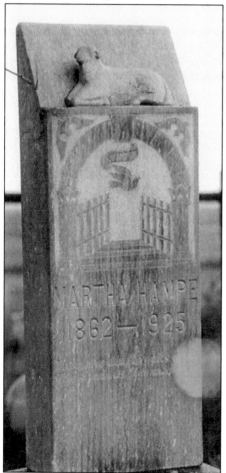

MARTHA HAMPE MONUMENT. Five individuals are known to have been buried in the Hampe Family Cemetery: Christoph Hampe (1865–1938) and Martha Hampe (1862–1925); Martha's parents, Heinrich (1828–1916) and Emilie Neitzel (1825–1907); and Lydia Hampe (1873–1959), Martha's younger sister and Christoph's second wife. The Hampe property was sold in the 1980s, at which time the bodies were moved to El Camino Memorial Park. (Courtesy RHC.)

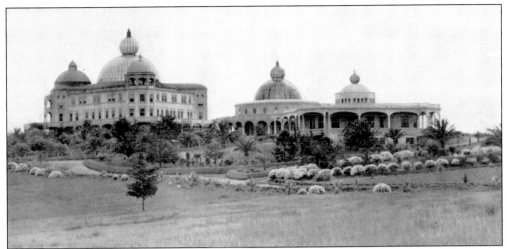

LOTUS-BY-THE-SEA CEMETERY AT THE THEOSOPHICAL INSTITUTE. Madame Katherine Tingley, a philanthropist and spiritualist, purchased land on Point Loma in 1897 for the establishment of a Theosophical School for the Revival of the Lost Mysteries of Antiquity. The Theosophical Institute was a combination commune/boarding school/artist colony that existed until 1942 and included a small cemetery. The property is now Point Loma Nazarene University. (Courtesy SDSUSC.)

TODAY'S LOTUS-BY-THE-SEA CEMETERY. Lotus-by-the-Sea Cemetery was located on the southwestern corner of the Theosophical Institute property. It abutted the U.S. Military Reservation and was at the top of an arroyo. This photograph was taken at the top of that arroyo. The military reservation is immediately to the left. (Courtesy SCIC.)

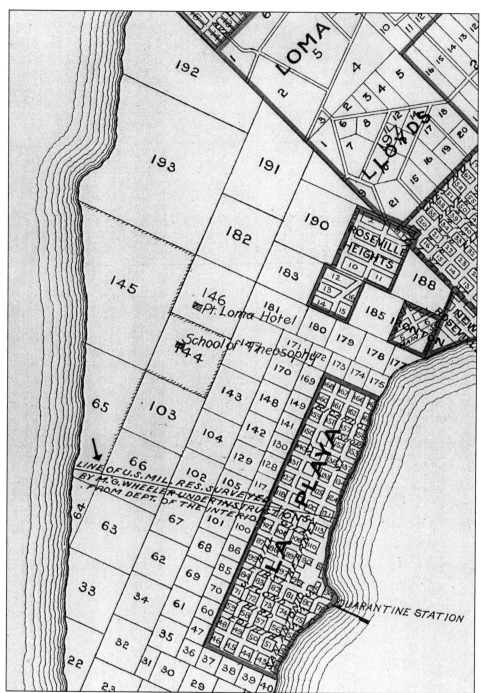

EARLY 20TH-CENTURY POINT LOMA PLOT MAP. Although Theosophists believed in cremation and did not memorialize human remains, their Lotus-by-the-Sea Cemetery contained at least five individuals. The last person believed to be buried there was Iverson L. Harris Sr., who died in 1921. As marked by the arrow, the cemetery was adjacent to the U.S. Military Reservation, an area that is now heavily developed. The Lotus-by-the-Sea Cemetery was either buried or destroyed long ago. (Courtesy SCIC.)

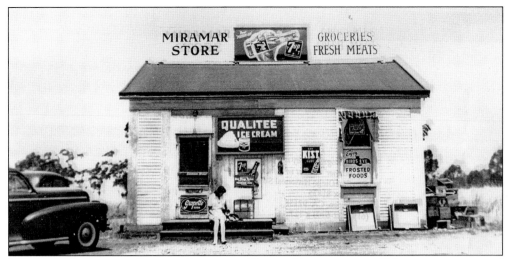

MIRAMAR STORE AND SCRIPPS CEMETERY. The small community of Miramar was centered around the intersection of Highway 395 (now Highway 15) and Miramar Road. This photograph shows the Miramar Store in the mid-1940s. The tiny Miramar Cemetery, or Scripps Cemetery, as it was commonly known, was believed to have been part of Edward Willis Scripps's 2,100-acre "Miramar" ranch, which he purchased some time around 1900. (Courtesy SCIC.)

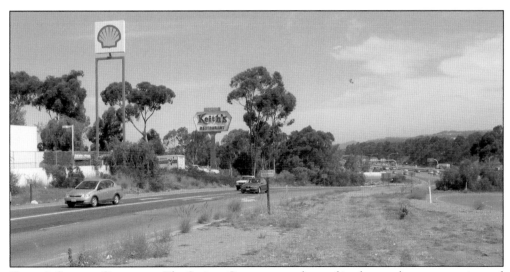

TODAY'S SCRIPPS CEMETERY. The Scripps Cemetery was located in the eucalyptus grove pictured here behind Keith's Restaurant. Six bodies were exhumed in the late 1960s and reinterred in Mount Hope Cemetery prior to the construction of Highway 15. The tiny burial ground was then covered by the highway embankment. Who the deceased were, or how they came to be there, is unknown. (Courtesy SCIC.)

SCRIPPS CEMETERY GRAVE MARKER. The May 5, 1965, *San Diego Union* reported this about the monument pictured here, "The 'headstone' is a carefully fashioned but still crude slab of wood a foot and a half wide, four feet tall. It is in a little-known cemetery 100 yards from the drone of autos on busy U.S. 395 and under the whining of jets landing at Miramar Naval Air Station. It is one of four graves sited in a grove of eucalyptus trees, which give the cemetery a primitive park-like atmosphere." This cemetery no longer exists. (Courtesy *San Diego Union*, May 5, 1965.)

Three

MEGA-CEMETERIES

MOUNT HOPE CEMETERY, EARLY 20TH CENTURY. Alonzo Horton chaired the committee that planned the City of San Diego's first official cemetery in 1869, deeming it a "matter of immediate and pressing necessity." Named Mount Hope Cemetery by Augusta Sherman, the 180-acre site was selected on the outskirts of the city for sanitary considerations. Mount Hope's first burial occurred at the end of 1869. The hearse in this *c.* 1910 photograph parallels the San Diego and Arizona Railroad (now the San Diego Trolley). Mount Hope's earliest graves can be seen in the background. (Courtesy SDHS.)

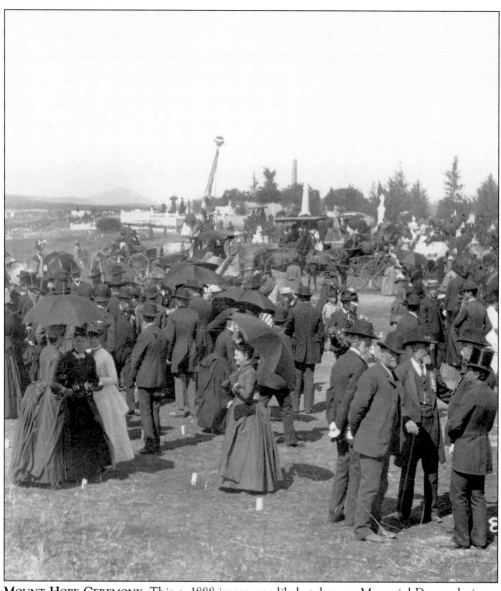

MOUNT HOPE CEREMONY. This c. 1888 image was likely taken on Memorial Day or during a military burial at Mount Hope Cemetery. Mount Hope exemplified the Rural Cemetery Movement and was the first of its kind to be established in San Diego County. This movement incorporated elements of city planning, architecture, art, and gardening, and replaced the harsh imagery of death with a shaded sculpture garden. The lack of development in the 1880s allows a clear view of San Miguel Mountain in the distance. (Courtesy SDHS.)

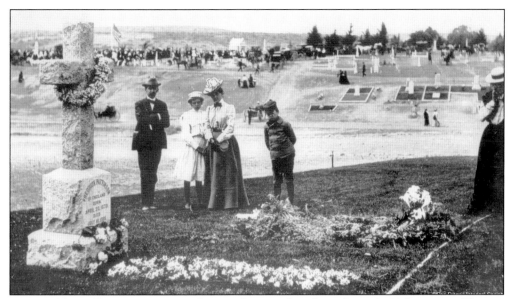

MOUNT HOPE, THEN AND NOW. The top photograph is from the early 20th century. There is considerable activity in the background at the Grand Army of the Republic (GAR) section of the cemetery, one of several sections allocated to fraternal organizations. Fredrick Pattinson's grave in the foreground is in the Independent Order of Odd Fellows (IOOF) section. The bottom photograph, taken from the same vantage point as the one above, shows some of the 76,000 burials that Mount Hope has hosted since its inception. In 1918, the cemetery became a perpetual-care facility when its increasingly dilapidated condition aroused the ire of San Diego residents, a situation that has since been remedied. As a city-owned operation, Mount Hope is not allowed to advertise or compete with privately owned cemeteries. (Above courtesy SDHS; below courtesy SCIC.)

Mount Hope's "Potter's Field." Appearances can be deceiving. This nondescript lot behind the Mount Hope administration building is Evergreen Cemetery, once San Diego County's "Potter's Field." Home to hundreds of unmarked graves holding the poor and the exceptionally unlucky, Evergreen is no longer in use. Unclaimed bodies are now buried in the active sections of Mount Hope. Greenwood Memorial Park (see page 82) can be seen through the trees at center. (Courtesy SCIC.)

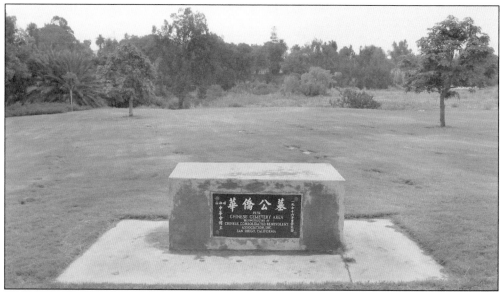

Chinese Monument. To accommodate San Diego's diverse population, Mount Hope has a Japanese section, Muslim section, and what was once a segregated Black section, to name but a few. The Chinese section shown here was, at one time, more of a temporary storage area. In accordance with pre-Communist Chinese cultural norms, the remains of Chinese immigrants were exhumed and returned to mainland China. (Courtesy SCIC.)

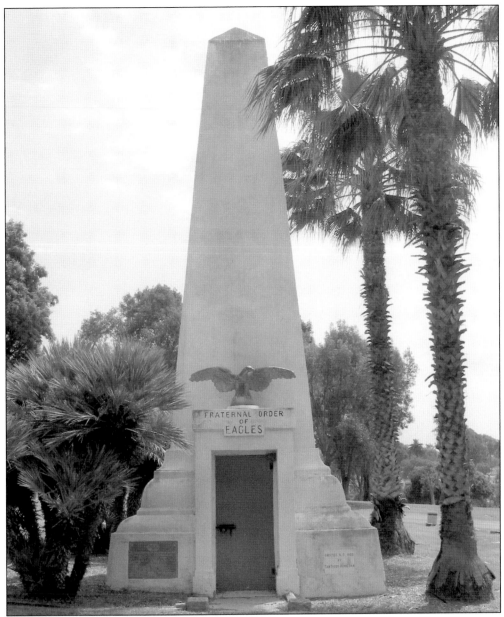

FRATERNAL ORDER OF EAGLES MONUMENT. The largest monument in Mount Hope Cemetery is this imposing white obelisk, constructed by the Fraternal Order of Eagles (FOE) in 1922 to mark their particular section of the cemetery. Like many such organizations of the time, the FOE provided a funeral benefit. One of their slogans is, "No Eagle was ever buried in a Potter's Field." (Courtesy SCIC.)

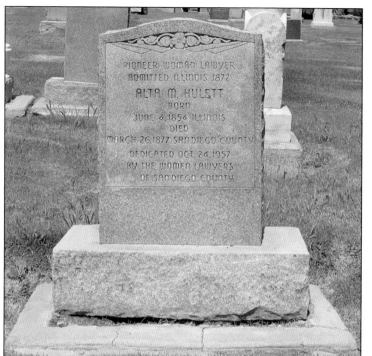

ALTA M. HULETT MONUMENT. Alta M. Hulett (1854–1877) was the first female attorney in the United States. As a teenager, she petitioned the Illinois Supreme Court for admission to the bar, but was rejected because of her gender. Hulett responded by successfully drafting and lobbying a bill through the state legislature that prohibited gender discrimination in employment. When Hulett passed the bar in 1873, she was the youngest attorney in the United States. (Courtesy SCIC.)

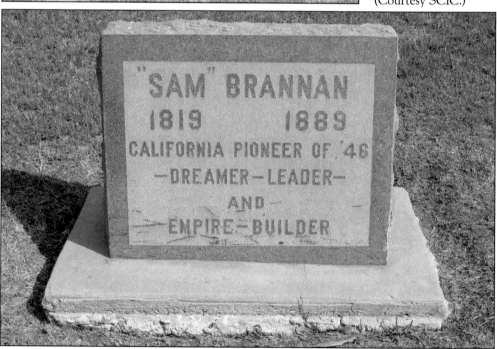

SAMUEL BRANNAN MONUMENT. California's first millionaire, Samuel Brannan (1819–1889) opened a general store in Northern California just before Marshall discovered gold there in 1848. He made a fortune selling supplies to the 49ers. Active in the Mormon Church until he was excommunicated, Brannan allegedly responded to accusations of using tithe money commercially with the quip, "I'll give the Lord his money when I get a receipt from the Lord." (Courtesy SCIC.)

THOMAS AND ANNA WHALEY MONUMENT. Married in 1853, Thomas Whaley (1823–1890), the son of a wealthy New York merchant, and Anna (1837–1913), a native of France, built and lived in the oldest existing brick structure in Southern California. Their home was constructed in 1856 in Old Town on the plot where Thomas had watched Yankee Jim hang four years earlier. (Courtesy SCIC.)

THOMAS AND ANNA WHALEY FAMILY. The Whaley House is purportedly home to multiple ghosts. In addition to Yankee Jim, modern visitors claim to have seen apparitions of Thomas, Anna, their toddler son, who died of scarlet fever, and even of Antonio Garra. Why Garra? Whaley was one of 12 men on the firing squad at Garra's execution. (Courtesy SCIC.)

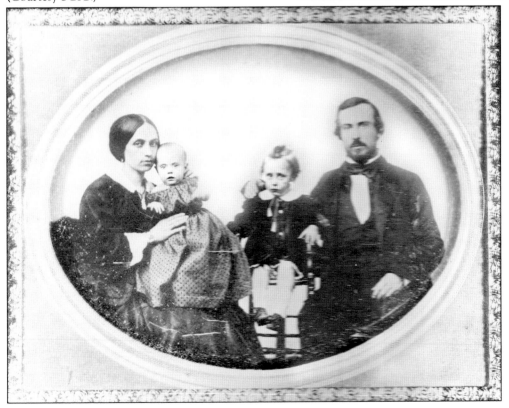

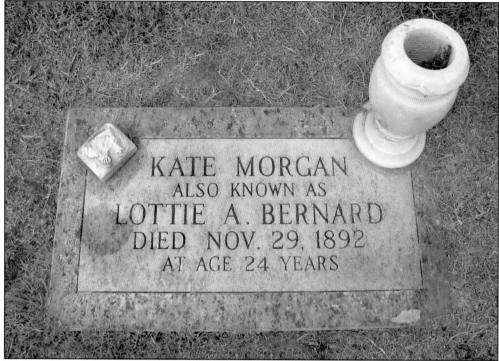

KATE MORGAN MONUMENT. Kate Morgan (1868–1892) is one of San Diego's most famous and controversial dead. A young woman checked into the Hotel Del Coronado alone under the alias "Lottie A. Bernard from Detroit, Michigan" on Thanksgiving evening, 1892. Five days later, she was found dead with what was believed at the time to be a self-inflicted gunshot wound to the head. After circulating a sketch of her face, police concluded that Lottie Bernard was Kate Morgan. (Courtesy SCIC.)

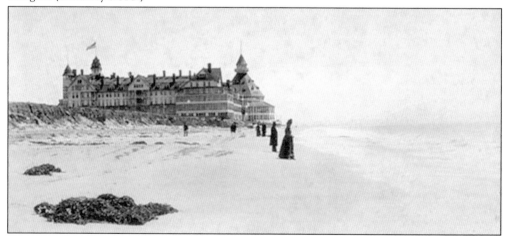

THE HOTEL DEL CORONADO. The ghost of Kate Morgan purportedly haunts room 3312 of the Hotel Del Coronado. Tales of paranormal activity at the hotel—flickering lights, unexplained voices, footsteps, gusts of wind, and ghostly apparitions—are linked to Morgan's 1892 apparent suicide. Days before her death, a visibly despondent Morgan told hotel staff that she was waiting for her "brother" (or perhaps her notorious card-shark husband, Tom Morgan) to join her. (Courtesy SCIC.)

ALONZO ERASTUS HORTON.
Known as the "Father of San
Diego," Alonzo Erastus Horton
(1813–1909) purchased and
developed most of today's
downtown area during the mid-
1800s. A Connecticut native,
Horton came to San Francisco
during the gold rush. He used
profits from his Northern
California supply and used-
furniture businesses to purchase
800 acres at 33¢ per acre in what
would become downtown San
Diego in 1867. (Courtesy SCIC.)

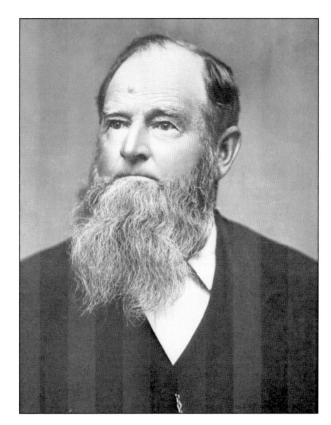

ALONZO ERASTUS HORTON MONUMENT. Following his
initial purchase, Horton returned to San Francisco and
actively marketed the delights of living in San Diego. A
relentless promoter, Horton purchased an additional 160-
acre parcel (Horton Addition) in 1867 and soon began
selling off lots. Horton's wealth swelled with the multiple
real estate booms and dwindled during the busts, but he
never lost sight of his vision of San Diego as a bustling
metropolis. (Courtesy SCIC.)

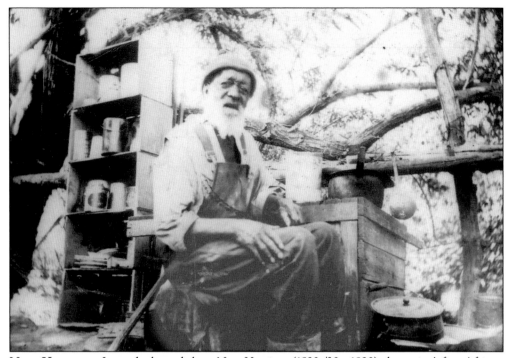

NATE HARRISON. Legends abound about Nate Harrison (1820s/30s–1920), the region's first African American homesteader. A former slave from the South who lived on Palomar Mountain in the late 19th and early 20th centuries, Harrison came to California during the gold rush but was emancipated when California entered the Union as a free state. Harrison migrated to Southern California, worked as a rancher, and ultimately homesteaded his mountain property. (Courtesy Kirby Collection.)

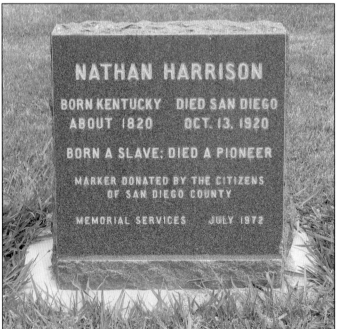

NATE HARRISON MONUMENT. In waning health, Harrison left his hillside homestead in 1919 and checked into the San Diego County Hospital. He died in 1920 and was placed in an unmarked grave at Mount Hope. In 1972, local historian Ed Diaz was astonished to find that this legendary African American pioneer had no grave marker. He then located Harrison's plot, raised the necessary funds, and had an appropriate marker placed on the grave. (Courtesy SCIC.)

ELISHA SPURR BABCOCK JR. MONUMENT. The civil engineer responsible for the construction of San Diego's historic Hotel Del Coronado in the 1880s, Elisha Spurr Babcock Jr. (1849–1922) developed over 4,000 acres of the city's property during his four decades in San Diego. His training and initial success in investment stemmed from railroad ventures in the Midwest. In addition to the world-class hotel, Babcock also built San Diego's inaugural electric-lighting system in 1904. (Courtesy SCIC.)

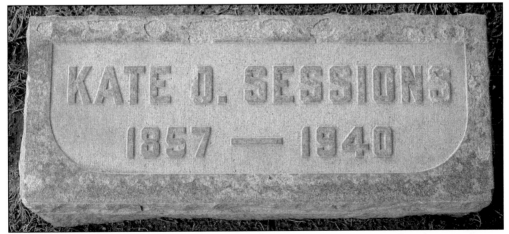

KATHERINE SESSIONS MONUMENT. One of California's premiere horticulturalists, Katherine Sessions (1857–1940) was San Diego's first official city gardener. Known as the "Mother of Balboa Park," she transformed San Diego from barren chaparral to lush native gardens. Sessions planted 400 trees each year in the city, many of which still stand. She was the first woman awarded the American Genetic Association's Frank N. Meyer medal for distinguished service in plant introduction. (Courtesy SCIC.)

RAYMOND THORTON CHANDLER.
America's foremost detective
novelist and creator of the "Philip
Marlowe" character, Raymond
Chandler (1888–1959) popularized
the detective story through
numerous magazine stories and
novels during the first half of the
20th century. Many of his novels
were made into movies, including
the 1946 *The Big Sleep*, starring
Humphrey Bogart and Lauren
Bacall. Chandler and his wife,
Cissy, moved to La Jolla in 1946
and lived there for the remainder of
their lives. (Courtesy SCIC.)

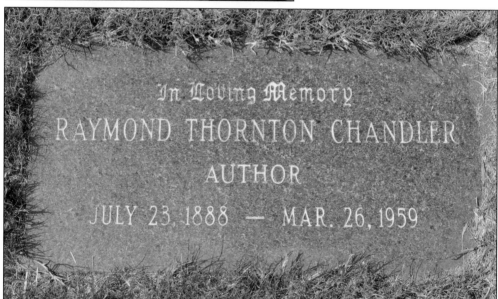

RAYMOND THORTON CHANDLER MONUMENT. Chandler's writing style was very distinctive. His
poetic metaphors—"The minutes went by on tiptoe, with their fingers to their lips" (*The Lady in
the Lake*, 1943)—and his hardboiled style—"I'm an occasional drinker, the kind of guy who goes
out for a beer and wakes up in Singapore with a full beard" ("The King in Yellow," 1938)—have
become norms for detective fiction. (Courtesy SCIC.)

BENBOUGH MEMORIAL (CYPRESS VIEW) MAUSOLEUM THEN. The Cypress View Mausoleum is located at the southeast corner of Mount Hope but is not connected with the cemetery. The enigmatic gated structure began as the Clover Lawn Crematory and Mausoleum in about 1922. It was purchased by Percival Benbough and became the Benbough Memorial Mausoleum in the late 1920s, and then was renamed Cypress View in the late 1930s. (Courtesy El Camino Memorial, Cypress View Chapel and Mausoleum.)

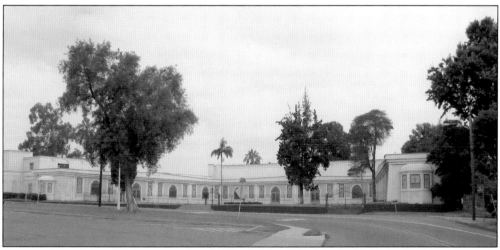

CYPRESS VIEW MAUSOLEUM NOW. Percival J. Benbough (1884–1942) was responsible for expanding Cypress View Mausoleum to its present size. "Percy" Benbough served as San Diego's police chief, and then mayor, before dying in office in 1942. His son Legler continued in the family mortuary business, building a second mausoleum directly across the street from Cypress View after World War II. (Courtesy SCIC.)

CYPRESS VIEW'S ROMAN STATUARY. Legler Benbough combined his love of art with his pride in Cypress View. The second of the two mausoleums—named collectively El Camino Memorial, Cypress View Chapel and Mausoleum—is decorated with antique furniture, ceramics, paintings and sculptures, including replicas of the 12 apostles from the Basilica of St. John Lateran in Rome. The Benboughs are entombed under the statue of St. Paul. (Courtesy SCIC.)

JOHN ALEXANDER "KING BID" MCPHEE 1887
BASEBALL CARD (OLD JUDGE CIGARETTES). A member
of the National Baseball Hall of Fame, John Alexander
McPhee (1859–1943) was the premiere second baseman
of the 19th century. He played for the Cincinnati Red
Stockings of the American Association from 1882 to
1889 and the Cincinnati Reds of the National League
from 1890 to 1899. In 1886, McPhee led the league in
home runs and recorded 529 putouts, a fielding record
that stands to this day. (Courtesy SCIC.)

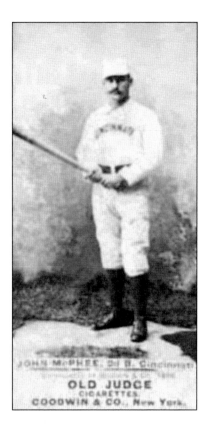

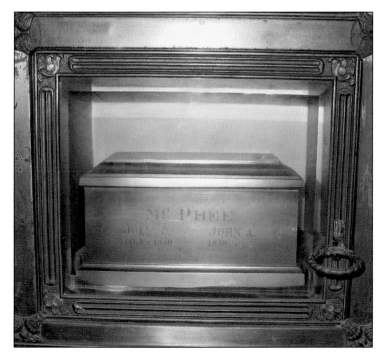

JOHN ALEXANDER
"KING BID" MCPHEE
MONUMENT. McPhee's
record-setting fielding
is all the more
impressive when it is
remembered that he
did it barehanded.
King Bid spent nearly
his entire career
without a glove,
choosing instead to
toughen his hands
by soaking them in
saltwater. In 1890, he
explained, "I cannot
hold a thrown ball
if there is anything
on my hands. The
glove business has
gone a little too far."
(Courtesy SCIC.)

AMELITA GALLI-CURCI URN. Born in Milan, Amelita Galli-Curci (1882–1963) was the leading soprano of her time. Although she was an award-winning pianist as a youth, Amelita's stunning singing talents were soon discovered by the composer Mascagni. In two years she went from a small local debut to singing "Bettina" in the premiere performance of Bizet's *Don Procopio.* Galli-Curci's popularity surged, and she toured the world during the early 20th century. (Courtesy SCIC.)

NAT (NATHANIEL GREENE) PENDLETON MONUMENT. An Olympic wrestler and actor, Nathaniel Greene Pendleton (1895–1967) gained fame by playing strongman Sandow in *The Great Ziegfeld* (the 1936 Academy Award winner for best picture). Pendleton, a silver medalist in freestyle heavyweight wrestling at the 1920 Summer Olympics in Belgium, re-created many of Sandow's feats of strength for the movie. His convincing performance as the legendary strongman led to numerous tough-guy movie roles. (Courtesy SCIC.)

ARCHIE MOORE (ARCHIBALD LEE WRIGHT). Archie Moore (1913–1998) knocked out more opponents than anyone in the history of organized boxing. A member of the International Boxing Hall of Fame, Moore fought for 27 years and held the light heavyweight title for 11 years. He is the only man to have fought both Rocky Marciano and Muhammad Ali. *Ring Magazine* ranked Moore as the fourth-best puncher of all time. (Courtesy SCIC.)

ARCHIE MOORE (ARCHIBALD LEE WRIGHT) MONUMENT. Moore was also an active boxing trainer. He worked with Ali, was George Foreman's cornerman for the 1973 title bout with Frazier, and coached the Nigerian boxing team in the Olympics. In addition, Moore established a local sporting program for underprivileged kids called "Any Boy Can," consulted with President Eisenhower on juvenile delinquency, and was granted a ceremonial key to San Diego by city officials. (Courtesy SCIC.)

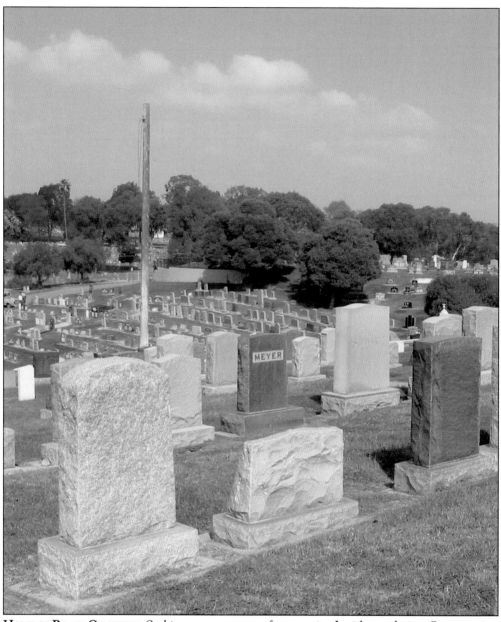

HOME OF PEACE CEMETERY. Seeking a new cemetery for a growing Jewish population, Congregation Beth Israel obtained the use of the southwest corner of Mount Hope Cemetery for a Jewish section in 1892. It has since grown into a separate mega-cemetery of its own. This image shows Home of Peace Cemetery as it appears today. The trees hide the trolley tracks on the left. Home of Peace is the only exclusively Jewish cemetery in San Diego County. While there is an interdenominational modern American trend toward small, flat grave markers, Jews do not follow this mortuary tendency. They prefer more traditional upright granite tablets, as can be seen here. (Courtesy SCIC.)

JOSEPH MANNASSEE MONUMENT. A native Prussian who first came to San Diego in 1853, Joseph Mannasse (1831–1897) was a prosperous Jewish entrepreneur who served multiple terms as a city trustee. Early in his San Diego ventures, he partnered with Marcus Schiller in a lumberyard. Known as "Mannasse Chico" or "Mannasito" because of his diminutive physical stature, Mannassee became one of the area's leading brokers during the late 19th century. (Courtesy SCIC.)

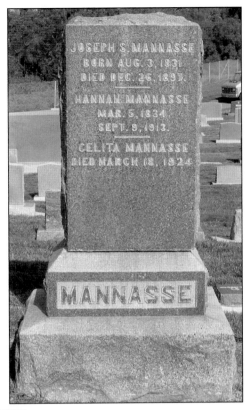

MARCUS SCHILLER MONUMENT. A successful businessman who reinvested much of his fortune in San Diego, Marcus Schiller (1823–1904) was a Prussian Jew who came to the region in the 1850s. He acquired many valuable local properties, including various rural ranchos and early tracts in both Old Town and New Town. Schiller's extensive philanthropy included contributions to San Diego's earliest telegraph lines, railroads, and parks. (Courtesy SCIC.)

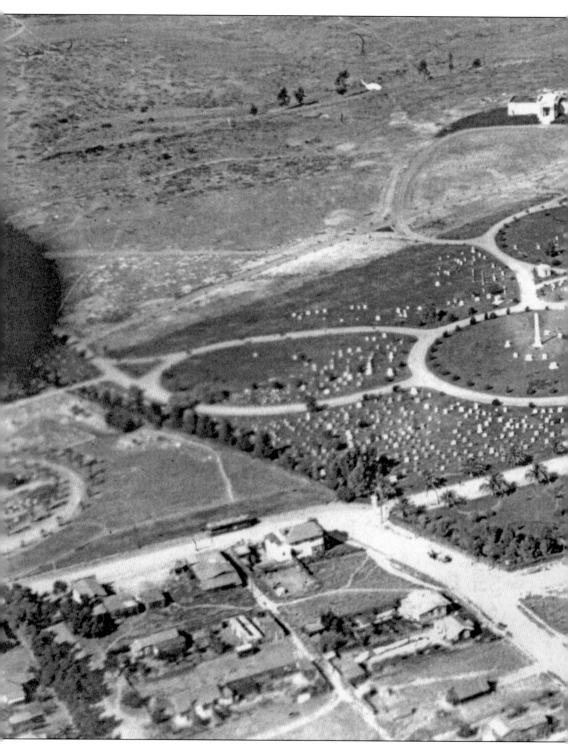

GREENWOOD MEMORIAL PARK AND MORTUARY. This *c.* 1918 aerial view of what was known as "Cemetery Hill" shows Greenwood Memorial Park and its enormous mausoleum at the center. Mount Hope Cemetery abuts Greenwood to the left. The trolley on Imperial Avenue, passing

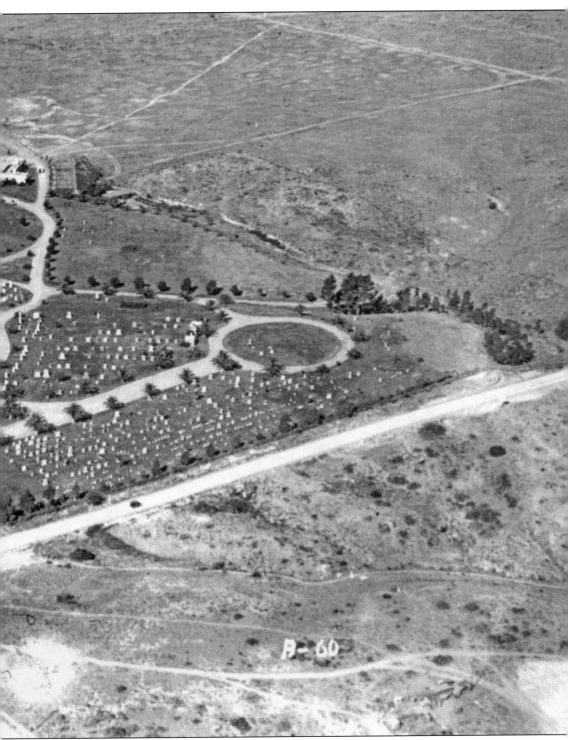

the corner of Mount Hope, is adjacent to the future location of Cypress View Mausoleum. (Courtesy SCIC.)

GREENWOOD ENTRANCE, C. 1920. Greenwood Memorial Park officially opened in 1908. With its sweeping garden landscape, it was typical of the Rural Cemetery Movement. Greenwood is the final resting place of many of San Diego's prominent citizens, and as such, it presents a diverse array of mortuary art. (Courtesy SCIC.)

GREENWOOD'S CATHEDRAL MAUSOLEUM, C. 1920. In 1939, the *San Diego Union* described Greenwood in the following manner, "It will never grow old and unkempt; it will never be less beautiful than it is now. And the mausoleum was built to withstand fire and shock and weather, to endure through the ages. Even the financial structure which is to provide for permanent upkeep and for future expansion, has been built with every known safeguard." (Courtesy SCIC.)

GREENWOOD'S BIBLE MAUSOLEUM. One of the largest buildings of its type in the world, Greenwood's Bible Mausoleum is but one of a series of structures at Greenwood that house the remains of tens of thousands of individuals. Greenwood's Chapel of the Chimes was built in 1919, its Cathedral Mausoleum opened in 1920, and the Bible and Shalom Mausoleums were finished in the 1950s. (Courtesy SCIC.)

LOUISA BRETAG MONUMENT. The first individual interred at Greenwood Memorial Park was Louisa Bretag. Although Greenwood did not officially open until 1908, Bretag died and was buried in December 1907. (Courtesy SCIC.)

ELK'S REST MONUMENT. As the name implies, Elk's Rest is the section of Greenwood Memorial Park reserved for the Benevolent Protective Order of Elks. The image of the clock on the base of the statue is frozen at the 11th hour, when Elks give a toast "to our absent Brothers." (Courtesy SCIC.)

JOSEPH SEFTON MONUMENT. Conspicuous displays in mortuary art typified the early 20th century, and many individuals of the time competed to have the tallest gravestone. The obelisk of Joseph Weller Sefton (1851–1908) dwarfs all others throughout San Diego County. In height, it is second only to the Bennington Monument in Fort Rosecrans National Cemetery (see page 104). Sefton was the founder of the San Diego Savings Bank, now San Diego Trust and Savings. (Courtesy SCIC.)

ULYSSES SIMPSON "BUCK" GRANT JR.
The second son of the 18th American president, "Buck" Grant (1852–1929) was involved with many investment deals. His successful ventures included the U.S. Grant Hotel on Broadway in downtown San Diego. Grant also participated in a number of schemes that failed, including the Grant and Ward investment firm, which collapsed in 1884 and nearly bankrupted the entire family. (Courtesy SCIC.)

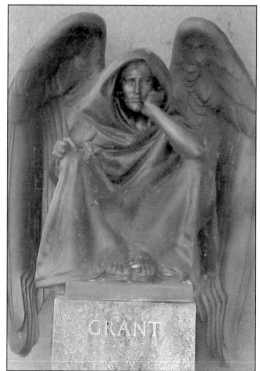

ULYSSES SIMPSON "BUCK" GRANT JR. MONUMENT. Grant worked in politics. He was his father's secretary during the senior Grant's second presidential term and unsuccessfully ran for the U.S. Senate in 1904. Grant, an investment capitalist who witnessed numerous financial ups and downs, died a month before Black Thursday, the stock market crash that began the Great Depression. The sculptor Henry Lukeman created the bronze Angel of Death that sits atop Grant's monument. (Courtesy SCIC.)

WILLIAM KETTNER. A U.S. Congressman who served multiple terms, William Kettner (1864–1930) was instrumental in bringing the Panama California Exposition to San Diego in 1915. He came to San Diego as a 21-year-old during the economic boom of the late 1880s. After being a member and then director of the city's chamber of commerce, Kettner served as a Democrat from California's 11th District in the U.S. House of Representatives from 1913 to 1921. (Courtesy SCIC.)

WILLIAM KETTNER MONUMENT. Nicknamed "The Million Dollar Congressman," Kettner was an adept politician who played key roles in acquiring money for numerous San Diego causes, including the dredging of the bay and the building of the region's many naval and marine facilities. His prominent role in San Diego's hosting of the global celebration upon the completion of the Panama Canal led to the designation of May 13, 1915, as "Kettner Day." (Courtesy SCIC.)

MOSES A. LUCE MONUMENT. A veteran of the Civil War and a Congressional Medal of Honor recipient, Moses A. Luce (1842–1933) was a San Diego pioneer. He moved to San Diego in 1873 and immediately opened a law practice. Luce became actively involved in the early development of the city, serving variously as postmaster, county judge, and railroad vice president. He also drafted the City of San Diego's first charter. (Courtesy SCIC.)

ADELAIDE MANTANIA LUCE

SEPT. 1858 — MAY 1928

MOSES A. LUCE

MAY 1842 — APR. 1933

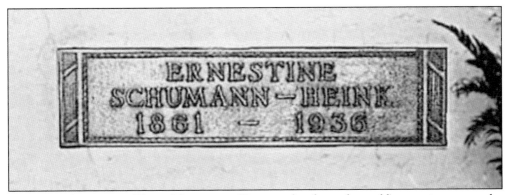

ERNESTINE SCHUMANN-HEINK MONUMENT. Known in her day as the world's preeminent contralto (lowest-pitched female voice) singer, Ernestine Schumann-Heink (1861–1936) popularized opera music for general audiences. Her tremendous vocal talents led the native Austrian across the world. She starred at San Diego's 1915 Panama-California Exposition, performing before 27,000 people at the Balboa Park Organ Pavilion and closing the festival on midnight, January 1, 1917, with "Auld Lang Syne." (Courtesy SCIC.)

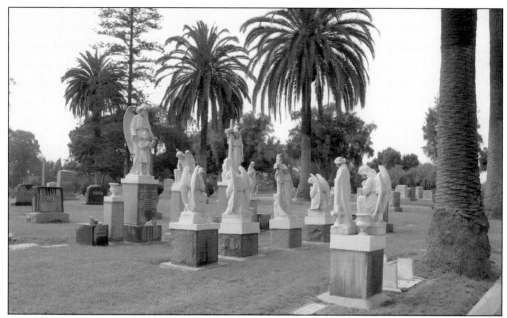

FREDERICK TANZER MONUMENTS. This unique grouping of white monuments amid Greenwood's more somber granite gravestones belongs to Frederick Tanzer (1861–1938). He purchased 16 burial plots and decorated them with fine Carrara statuary, some of the highest-quality, Italian white marble in the world, as memorials to relatives and friends. Interestingly only Tanzer and his wife were buried there; the other graves remain empty. (Courtesy SCIC.)

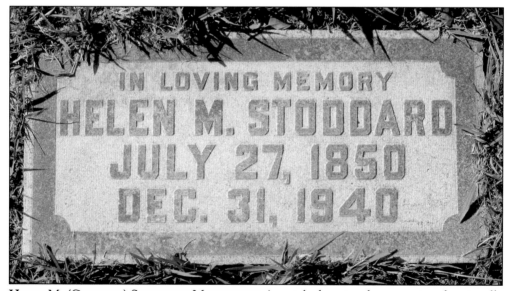

HELEN M. (GERRELLS) STODDARD MONUMENT. A social advocate who campaigned nationally against alcohol and tobacco use, Helen M. Stoddard (1850–1940) was the first woman in California to run for Congress. As president of the Texas Women's Christian Temperance Union in 1891, Stoddard convinced the Texas state legislature to raise the age of girls' sexual consent from 12 to 15, to outlaw the sale of cigarettes to minors, to establish a pure-food law, and to reduce child labor. (Courtesy SCIC.)

HAROLD BELL WRIGHT MONUMENT. The bestselling American author of the first quarter of the 20th century, Harold Bell Wright (1872–1944) was the first novel writer to become a millionaire by his trade. He wrote numerous books, plays, and magazine articles. Although critics widely condemned Wright's work for its simplicity and heavy-handed morality, his publisher estimated that over 10 million of his novels had been sold. (Courtesy SCIC.)

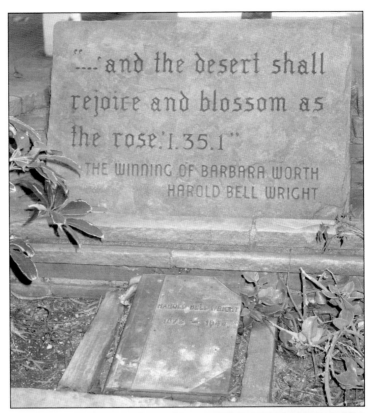

ROBERT I. ELLIOTT MONUMENT. A major-league baseball player and manager, Robert I. Elliott (1916–1966) won the National League's Most Valuable Player award in 1947. A six-time All-Star, Elliott amassed over 2,000 hits during his 15-year career. He played in the Pacific Coast League with San Diego in 1954 and managed the Padres from 1955 to 1957. (Courtesy SCIC.)

BUONO FAMILY MONUMENT. San Diego native Victor Buono (1938–1982) was a legendary character actor. After joining the San Diego Globe Theater Players at 18, he starred in the 1962 movie *What Ever Happened to Baby Jane?* and became a regular on the *Batman* television series as "King Tut." Buono's ashes are within in his wife's Greenwood crypt. Greenwood houses several actors, including two Keystone Kops (Walter Bystrom and Herbert Trafton) and one of the *Wizard of Oz*'s singing munchkins (Marie Maroldo). (Courtesy SCIC.)

WALTER FULLER MONUMENT. A renowned jazz trumpeter and civil-rights activist, Walter Fuller (1910–2003) was the last surviving member of the Earl Hines Orchestra. When Fuller headed his own band and began playing local clubs in the 1940s, his protest successfully changed the Club Royal's segregated seating policy, which had forced black customers to stand in the back. Fuller also succeeded in desegregating the local musicians' union-chapter listings. (Courtesy SCIC.)

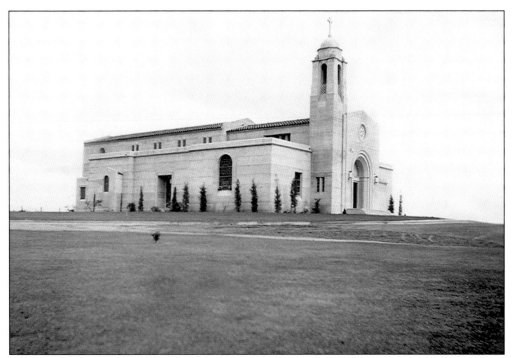

HOLY CROSS CEMETERY AND MAUSOLEUM THEN. Dedicated in 1919 and initially reserved exclusively for Catholics, Holy Cross Cemetery saw its first interment in 1918. The Holy Cross Mausoleum, constructed in 1939, is at the highest point of the cemetery. It was once considered the second-strongest building in San Diego and was designated as a fallout shelter. (Courtesy *The Southern Cross.*)

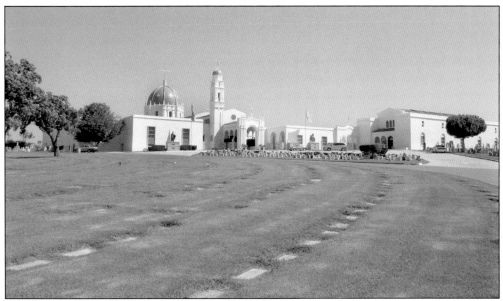

HOLY CROSS CEMETERY AND MAUSOLEUM NOW. The photograph shows Holy Cross Mausoleum as it appears today. Expansion took place in 1945 and in 1956. The blue and gold dome, added in 1956, is a familiar landmark to commuters on Highway 94. (Courtesy SCIC.)

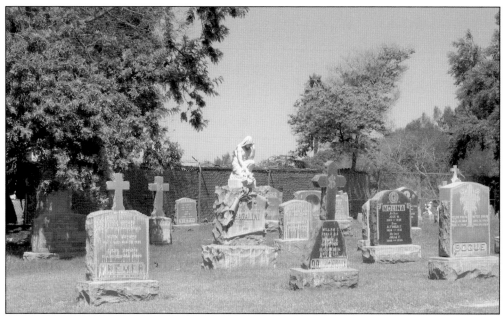

HOLY CROSS CEMETERY HISTORIC SECTION. The oldest section of Holy Cross Cemetery, with its elaborate granite monuments, is reminiscent of Mount Hope Cemetery or Greenwood Memorial Park. Catholic symbolism is quite prominent, as are Italian and Portuguese surnames. (Courtesy SCIC.)

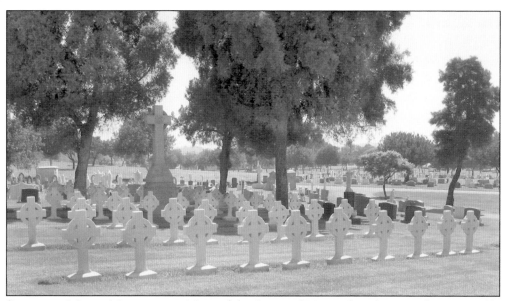

SISTERS OF MERCY MONUMENTS. Many of the Sisters of Mercy, the religious order responsible for establishing the Carmel Valley Cemetery, are buried together at Holy Cross Cemetery. The large granite cross is a memorial to Mother Mary Michael Cummings, their first superior in San Diego. Ironically, it was the establishment of Holy Cross that contributed to the demise of Carmel Valley and Calvary Cemeteries. (Courtesy SCIC.)

CHARLES FRANCIS BUDDY.
The first bishop of the Roman
Catholic Diocese of San Diego,
the Most Reverend Bishop Charles
Buddy (1887–1996) founded the
University of San Diego in 1949
and served as its first president
until 1966. A priest for over 50
years, Buddy was particularly adept
at fund-raising for the construction
of mission churches and schools
that served the local community.
(Courtesy SCIC.)

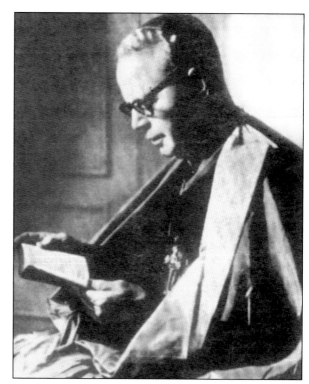

**CHARLES FRANCIS BUDDY
MEMORIAL.** In addition to Buddy,
Holy Cross Cemetery holds a broad
range of well-known Southern
Californians, including Charlotte
Henry (Dempsey), the lead in *Alice
in Wonderland* (1933), and Johnny
Morey Downs ("Johnny" from the
Our Gang movies and *The Little
Rascals* television series). Holy Cross
also houses the remains of Andrew
Cunanan, the serial killer who
murdered Italian designer Gianni
Versace in 1997 and was the first
San Diegan on the FBI's "Ten Most
Wanted" list. (Courtesy SCIC.)

EL CAMINO MEMORIAL PARK THEN. El Camino Memorial Park in Sorrento Valley is the most recent cemetery to be established within the city of San Diego. Founded in 1960, local planners intended to create a 220-acre memorial park that would also serve as a point of interest to visitors. This 1966 photograph shows the front gate on Carroll Canyon Road. Clever landscaping now hides all but the gate and the hilltop mausoleums. (Courtesy SDHS.)

EL CAMINO MEMORIAL PARK NOW. The stylized bell tower was eventually moved from the front gate to Mausoleum of the Bells Terrace, overlooking El Camino Memorial Park. The hilltop terrace is the location of a number of large mausoleums and family crypts. (Courtesy SCIC.)

EASTERN ORTHODOX CHRISTIAN CHAPEL. The centerpiece of the Saint Demetrios Orthodox Garden is an Eastern Orthodox Christian chapel, a replica of the Saint Demetrios Chapel in Kamari, Greece. El Camino Memorial Park is one of the few cemeteries in the United States with a chapel especially appointed for the Eastern Orthodox faith. (Courtesy SCIC.)

"STATIONS OF THE CROSS" COLUMBARIA. El Camino Memorial Park is a "lawn park" cemetery, one that consists mostly of flush markers on broad expanses of grass. El Camino is divided into more than 40 lawns, many specific to a particular religious affiliation, fraternal organization, or occupation. This particular section is dotted with columbaria, each topped by a marble statue depicting a Station of the Cross. (Courtesy SCIC.)

MILBURN STONE MONUMENT. An Emmy-winner with a star on Hollywood's Walk of Fame, Milburn Stone (1904–1980) played the hotheaded Dr. Galen Adams ("Doc") on the show *Gunsmoke*, the longest-running dramatic series in the history of television. Inducted posthumously into the Western Performers Hall of Fame, Stone also received an honorary doctorate from St. Mary of the Plains College in Dodge City, Kansas. (Courtesy SCIC.)

BILLY (WILLIAM BOONE) DANIELS MONUMENT. The first African American to host a network variety show, Billy Daniels (1915–1988) had an extensive music and acting career that included work in radio and television and on Broadway. *The Billy Daniels Show* aired weekly in 1952, and although it was short-lived, he later performed extensively on Broadway, costarring in *Golden Boy* with Sammy Davis Jr. from 1964 to 1965. (Courtesy SCIC.)

JOAN AND RAY KROC PORTRAITS AND MONUMENTS. Billionaires Ray (1902–1984) and Joan (1928–2003) Kroc are two of the best-known San Diegans. Ray partnered with the McDonald brothers in their fast-food restaurants in 1954. Joan dedicated her life to philanthropic causes; she was as renowned for her charity as Ray was for his ruthlessness in business. During her life, Joan donated $1.5 billion to the Salvation Army, $200 million to National Public Radio, and $50 million to the Peace Institute at the University of San Diego. Conversely, Ray once declared, "If my competitor was drowning, I'd stick a hose in his mouth and turn on the water." (All courtesy SCIC.)

JONAS EDWARD SALK. The scientist who developed a vaccine for polio, Jonas Salk (1914–1995) became a public hero for both finding the cure to the deadly disease and altruistically refusing to patent it. He developed the polio vaccine in 1952 while head of the Virus Research Laboratory at the University of Pittsburgh. The publishing of his successful test results spawned a nationwide vaccination plan. (Courtesy SCIC.)

JONAS EDWARD SALK MONUMENT. During the early 1960s, Salk was enticed to San Diego by Mayor Dail, a polio survivor himself. Dail promised Salk 70 acres to build a medical research center just west of the site of the newly proposed University of California at San Diego campus. Salk accepted the offer and, in 1963, founded the Salk Institute for Biological Sciences in La Jolla. He spent the last few years of his life trying to develop a vaccine for AIDS. (Courtesy SCIC.)

PETE ROZELLE. Commissioner of the National Football League for 29 years and the man who invented the Super Bowl, Pete Rozelle (1926–1996) was a masterful promoter who excelled at public relations. During his 1960–1989 tenure as commissioner, the NFL expanded from 12 to 28 teams, grew in income from $20 million to $4 billion, and gained a Congressional exemption from the Sherman Anti-Trust Act. (Courtesy SCIC.)

PETE ALVIN ROZELLE MONUMENT. Rozelle's primary vision was that a sporting event could be more than game; it could be a show. His business model is now emulated by all major American sports. Rozelle was immediately drafted into the navy after his 1944 graduation from Compton High School. Following his military service, he worked a variety of sports-publicity jobs before becoming general manager of the NFL's Los Angeles Rams in 1957. (Courtesy SCIC.)

WILLIAM A. NIERENBERG MONUMENT. A member of the National Academy of Sciences, William Nierenberg (1919–2000) founded the Atomic Beam Research Group at UC-Berkeley's Lawrence Radiation Laboratory. A global statesman for science, he served on President Eisenhower's Science Advisory Panel on Antisubmarine Warfare and was NATO's secretary general for scientific affairs. Nierenberg served as director of UC-San Diego's Scripps Institution of Oceanography for 21 years before retiring in 1986. (Courtesy SCIC.)

JOSEPH COORS SR. MONUMENT. "Joe" Coors (1917–2003), grandson of the founder of the Coors Brewing Company, transformed the family company into the third-largest brewery in the United States. Coors was a staunch conservative. He established The Heritage Foundation, a right-wing think tank, actively fought with organized labor leaders over the unionization of his breweries, and served on Reagan's "kitchen cabinet" of advisers during the 1980s. (Courtesy SCIC.)

Four

MILITARY CEMETERIES

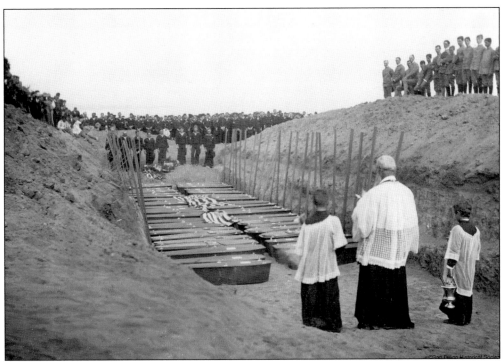

BENNINGTON BURIAL CEREMONY, 1905. Today's Fort Rosecrans National Cemetery started in 1879 as the U.S. Army's Post Cemetery, San Diego Barracks (Point Loma). It contained only 32 graves at the beginning of the 20th century, even after the "gathering-in" of veterans in 1887. The cemetery's population doubled when the USS *Bennington* exploded in San Diego Bay in 1905. A total of 66 sailors were killed, with 35 buried in what became colloquially known as the "Bennington Cemetery." (Courtesy SDHS.)

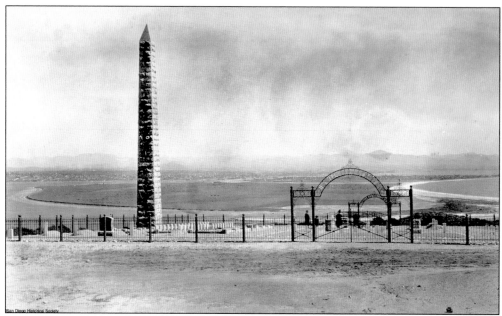

U.S. MILITARY CEMETERY, C. 1908. The original graves of the Post Cemetery are immediately inside the gate, which reads "U.S. Military Cemetery." This graveyard contains the remains of many early San Diegans, including burials transferred from La Playa Cemetery, American soldiers from Mission San Diego de Alcalá, and those killed in the Battle of San Pasqual. The 75-foot obelisk marks the "Bennington Plot." (Courtesy SDHS.)

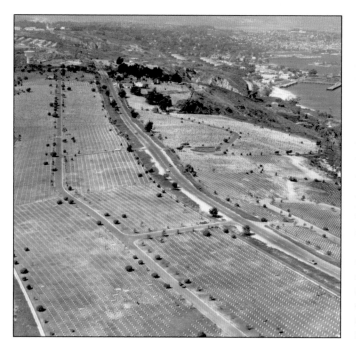

FORT ROSECRANS NATIONAL CEMETERY, 1966. The campaign for national cemetery status, which had continued for almost 30 years, reached fruition when the secretary of war conferred the designation in 1934. Fort Rosecrans National Cemetery was officially dedicated on May 30, 1937. At the time, it was eight acres in size; now it encompasses 71.34 acres and includes the remains of approximately 90,000 servicemen and family members. (Courtesy SDHS.)

SAN PASQUAL BATTLEFIELD MONUMENT. A boulder from the San Pasqual Battlefield marks the grave of the "San Pasqual Dead," the most well-traveled of all deceased San Diegans. Killed in 1846, the combatants were exhumed from the battlefield in 1848 and moved to the "Government Graveyard" in Old Town. In 1874, the bodies were transferred to a mass grave near "Hill 80" (Midway Drive and West Point Loma Boulevard). These "unknown dead" reached their final resting place at Fort Rosecrans in 1889. (Courtesy SCIC.)

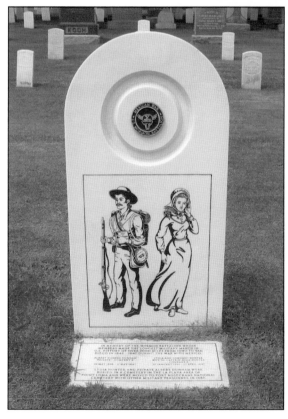

MORMON BATTALION MONUMENT. A memorial to the Mormon Battalion stands in Fort Rosecrans National Cemetery above La Playa. It marks the final resting place of Lydia Hunter and Pvt. Albert Dunham, who were moved to Fort Rosecrans from La Playa Cemetery in 1887. Hunter died on April 26, 1847, six days after her son Diego was born. Diego Hunter was the first American born in California. (Courtesy SCIC.)

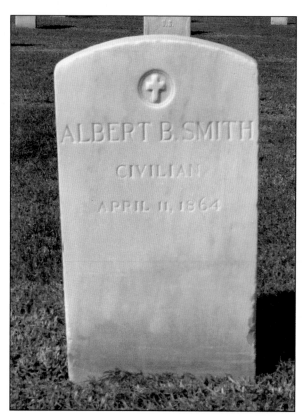

ALBERT SMITH HEADSTONE. One of the well-known names in early San Diego history, Albert Smith (?–1864) became a local legend for his role in the Mexican-American War. A sailmaker aboard the whaling ship *Stonington*, Smith was put ashore to sabotage the guns at Fort Stockton (on Presidio Hill), enabling American forces to retake the settlement above Old Town. (Courtesy SCIC.)

ALBERT SMITH FOOTSTONE. Smith has gained near mythical status; amidst enemy fire, he allegedly climbed the flagpole at Fort Stockton and nailed the American flag to it, the halyard having been cut. A small boulder marks the foot of his grave; it reads, "Albert Smith, Civilian. Spiked guns at Fort Stockton. Raised American flag under fire, 1846." (Courtesy SCIC.)

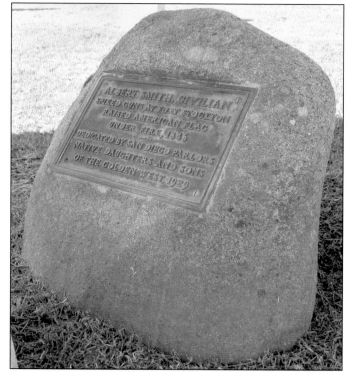

MASON CARTER. A recipient of the Indian Wars Congressional Medal of Honor, Mason Carter (1834–1909) led a distinguished military career that included service during the Civil War and subsequent Indian Wars. He joined the navy at 14 and then entered the army two years later. After 50 years of active duty, he retired from the service and became professor of military science at the University of the South, in Sewanee, Tennessee. (Courtesy SCIC.)

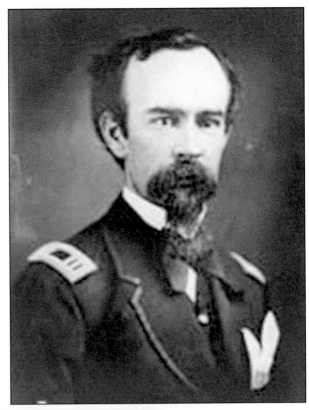

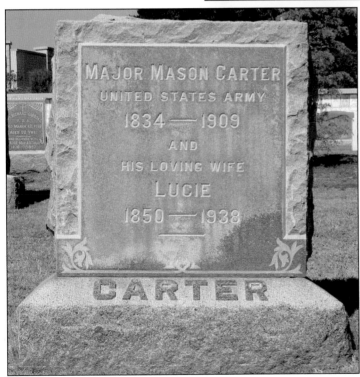

MASON CARTER MONUMENT. Carter was the first Congressional Medal of Honor recipient to be interred at Fort Rosecrans National Cemetery. Gen. Nelson Miles endorsed Carter for the Medal of Honor for "most distinguished gallantry in action against the Nez Perce Indians at Bear Paw Mountain, Montana, on September 30, 1877, in leading a charge under a galling fire in which he inflicted great loss upon the enemy." (Courtesy SCIC.)

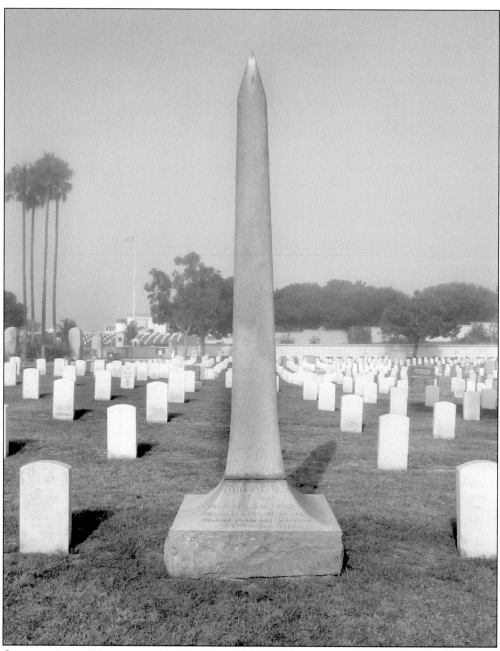

CHARLES ALLER MONUMENT. Charles Aller (1888–1921) has a unique gravestone at Fort Rosecrans National Cemetery. His obelisk is a reminder of an almost forgotten incident in aviation history. Chief Boatswain's Mate Charles Ivan Aller was an aviation rigger in a U.S. Navy detachment sent to collect the British airship R38 (American designation ZR2). The airship broke up during its acceptance flight on August 24, 1921, and crashed in flames into the River Humber, resulting in 44 British and American casualties, including Aller. (Courtesy SCIC.)

ALBERT LEROY DAVID MONUMENT. A Congressional Medal of Honor recipient, Albert Leroy David (1902–1945) led the capture of a German submarine off the coast of French West Africa on June 4, 1944. This seizure was the navy's first successful boarding and capture of an enemy man-of-war since the early 1800s. Although the German submarine could have detonated at any moment, David stayed on board, led the salvage operations, and enabled the vessel to be taken to Bermuda. (Courtesy SCIC.)

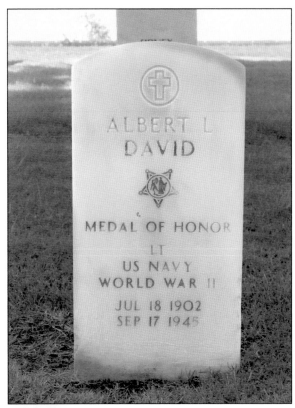

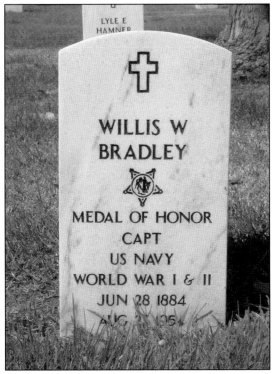

WILLIS WINTER BRADLEY MONUMENT. Willis Winter Bradley (1884–1954) served in World War I, received the U.S. Navy Peacetime Congressional Medal of Honor for "extraordinary heroism and devotion to duty while serving on the U.S.S. *Pittsburgh*," and was elected to the 80th U.S. Congress as a California Republican representative, serving from 1947 to 1949. He also served as governor of Guam from 1929 to 1931 and as captain of the Pearl Harbor Navy Yard from 1933 to 1935. (Courtesy SCIC.)

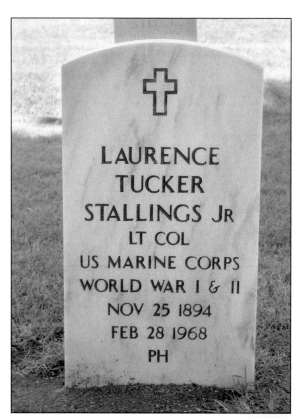

LAURENCE TUCKER STALLINGS JR. MONUMENT. A U.S. Marine lieutenant colonel who lost a leg in combat during World War I, Laurence Tucker Stallings (1894–1968) was a prolific screenwriter whose work emphasized anti-war sentiments. Stallings and Maxwell Anderson's play *What Price Glory?* stunned and engrossed audiences with its irreverent brutality. Despite a lengthy writing career that routinely identified the senselessness of war, Stallings also served in World War II (with an artificial leg). (Courtesy SCIC.)

LLOYD BUCHER MONUMENT. Commander of the USS *Pueblo*, Lloyd Bucher (1927–2004) and his crew were attacked by North Korean torpedo boats in 1968. The North Koreans captured, held, and tortured Bucher and his men for 11 months before releasing them. It took 20 years for the U.S. military to award POW medals to these men; the government insisted that since the country was not at war with North Korea when the attack occurred, the men were not prisoners of war. (Courtesy SCIC.)

Five

CEMETERY MYTHS

THEODOR "DR. SEUSS" GEISEL MONUMENT. The myth is that the ashes of Dr. Seuss are sealed inside his bronze statue. Theodor Seuss Geisel (1904–1991) was a modern-day Mother Goose who wrote and illustrated nearly 50 books under the moniker Dr. Seuss. His books have sold over 200 million copies and include such classics as *The Cat in the Hat, Green Eggs and Ham*, and *Oh, the Places You'll Go!* Winner of a special Pulitzer Prize in 1984, Dr. Seuss was also a passionate patriot who enlisted immediately following the bombing of Pearl Harbor and rose to the rank of colonel. A bronze statue of Geisel and his famed feline stands outside of the University of California, San Diego library, which also houses an extensive Seuss archive. Although many San Diegans believe that Dr. Seuss's ashes are in the center of this hollow statue, they are not. His ashes remain with his widow in their La Jolla home. (Courtesy SCIC.)

JOSEPH FREDERICK RUTHERFORD. The myth is that "Judge" Joseph Rutherford is buried behind his home, the Beth-Sarim House. Rutherford (1869–1942), president of the Watchtower Bible and Tract Society, was a controversial religious leader who deeded his extravagant, 10-room mansion to King David of Israel, Moses, Abraham, Gideon, Isaac, Samson, and other biblical figures named in Hebrews 11. He led the Russellites, now known as Jehovah's Witnesses, after their founder died in 1916. (Courtesy SCIC.)

THE "BETH-SARIM HOUSE." Although Rutherford, the self-proclaimed judge, formally requested to be buried on his lavish Kensington property at 4440 Braeburn Road, the County of San Diego turned him down. There is no evidence of a grave on the property. An unfinished concrete structure behind the Beth-Sarim House is *not* his purported mausoleum. (Courtesy SCIC.)

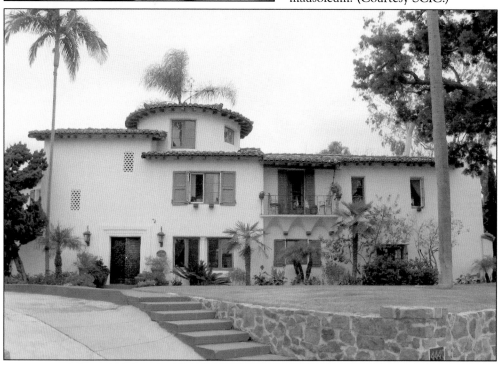

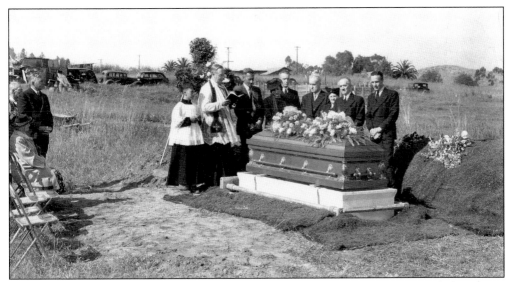

PRINCESS FILOMENA BURIAL CEREMONY, 1941. The myth is that there is a Polish princess buried under Highway 94. Princess Filomena (Wojciechowski) Sledzinski (1876–1941) of Przemysl, Poland, lived in Lemon Grove at the intersection of College and Broadway Avenues. She died in 1941 and was buried on the family property. The above photograph shows Monsignor John M. Hegarty, vicar general of the San Diego Catholic Diocese, presiding over the Princess Filomena funeral. (Courtesy Lemon Grove Historical Society.)

SLEDZINSKI FAMILY PROPERTY. This undated photograph, with Polish and American flags flying at half-staff, shows the property of John and Filomena Sledzinski with the memorial to Princess Filomena. Contrary to popular belief, Princess Filomena's body was exhumed and reburied next to her husband's remains at Greenwood Memorial Park before the construction of Highway 94. (Courtesy SDHS.)

NAVAL TRAINING CENTER GOLF COURSE. The myth is that there is a body buried under the fairway at the Naval Training Center golf course. The "Sail Ho" Golf Course at the old Naval Training Center (NTC) is located at the corner of Rosecrans and Lytton Streets on Point Loma. Two "gravestones" next to the fairway, in view of the pro shop, have sparked the rumor that golfers are playing on a gravesite. (Courtesy SCIC.)

WOODWORTH PLAQUES. There are two bronze plaques under a eucalyptus tree on the golf course. They are a memorial to U.S. Navy captain Edwin Burke Woodworth (1888–1967), the Naval Training Center's first executive officer. The head groundskeeper allegedly planted the eucalyptus tree there specifically for the memorial. It is not known whether Woodworth is buried elsewhere or if the memorial marks his cremated remains. Nonetheless, his corpse is *not* buried at the golf course. (Courtesy SCIC.)

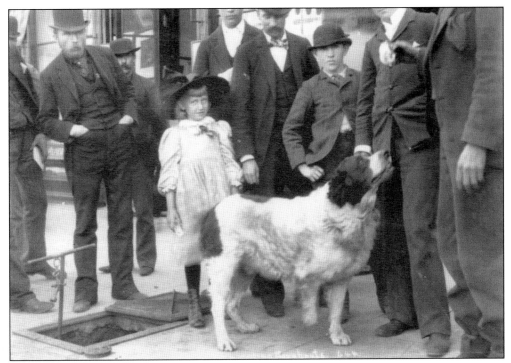

TOWN DOG EYES DONUT. The myth is that "Bum the Dog" is buried at Balboa Park or one of the city's two pet cemeteries. A Saint Bernard puppy that arrived in San Diego on a steamship from San Francisco in the late 1880s, Bum the Dog (1886–1898) immediately charmed the local inhabitants and became the town pet. The legendary canine rode with firemen in their wagons, battled alcoholism, and survived a collision with a train, losing his right front paw in the process. (Courtesy SDHS.)

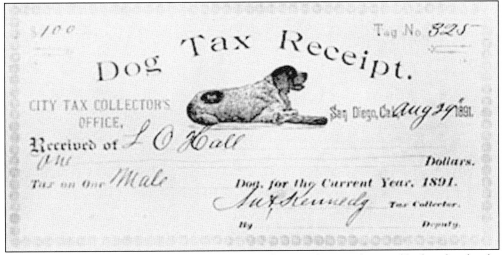

BUM'S IMAGE ON HISTORIC DOG LICENSE. Named "Bum" because he steadfastly refused to be adopted and chose to nap in the center of San Diego's busiest walkways, San Diego's town dog survived on daily offerings of food from local vendors, who proudly displayed "Bum Eats Here" signs in their windows. When the city enacted the dog-license law, they allowed for a Bum exception and even placed his likeness on the first official dog-tax receipts. (Courtesy SCIC.)

MAP OF COUNTY POOR FARM, 1907. Bum struggled with rheumatism in his later years. The board of supervisors passed an edict in the late 1890s, allowing Bum to stay at the old county hospital, located on the San Diego County Poor Farm, which today is under Highway 163. It was down the hill from the new county hospital, labeled on this map as "County Hospital." A 1907 map shows the poor farm where Bum spent his last days. (Courtesy SCIC.)

BUM'S FINAL RESTING PLACE. Bum died in 1898 and was placed in an unmarked grave on the grounds of the old county hospital. The area has since been redeveloped and cut by two major highways, Interstates 8 and 163. In matching up landmarks from old and new maps, it is apparent that Bum's remains rest somewhere below where the two highways intersect or under the adjacent T.G.I. Friday's parking lot. (Courtesy SCIC.)

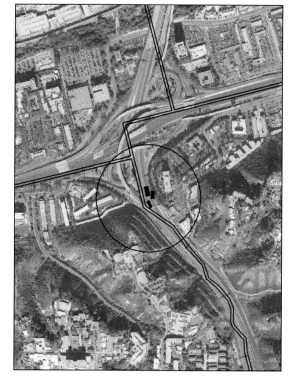

SORRENTO VALLEY PET CEMETERY. There are two pet cemeteries in San Diego, neither of which contain the remains of Bum the Dog. Sorrento Valley Pet Cemetery and Crematory, located on Sorrento Valley Road, was founded by the Turners in 1955. They designed it to be a "lawn park," with flush markers on manicured grass. This photograph was taken in 1956. (Courtesy Sorrento Valley Pet Cemetery [SVPC].)

THE SCATTER TREE. Sorrento Valley is a full-service cemetery; it has lawn burials, a mausoleum, a columbarium for cremated remains, caskets and urns, a chapel for services, and a crematorium that can handle a small pony. The "Scatter Tree" is a unique memorial; the fill around the tree is not gravel but the cremated remains of hundreds of pets. (Courtesy SCIC.)

SAN DIEGO PET MEMORIAL PARK. Secluded in a valley at the end of Crestmar Point, north of Miramar Road, San Diego Pet Memorial Park is hidden from the public eye. Established by the Limpus Family, this "lawn park" cemetery has supplied the mortuary needs of San Diegans with pets since 1962. A full-service establishment, it has interred or cremated approximately 35,000 animals. This photograph was taken in 1972. (Courtesy San Diego Pet Memorial Park [SDPMP].)

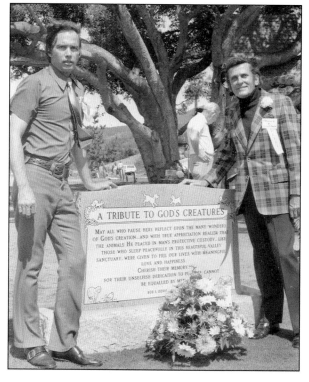

PET MEMORIAL. "A Tribute to God's Creatures" was dedicated on National Pet Memorial Day in 1972 at San Diego Pet Memorial Park. While the majority of animals interred in the cemetery are dogs and cats, rabbits, birds, and horses are also well represented. (Courtesy SDPMP.)

118

Six

GRAVESTONE TRENDS

JOHN MACNAMIE COMPANY ADVERTISEMENT, 1871. This image, a late–19th century advertisement for a New England gravestone-carving company, is full of relevant mortuary-art details. By the late 1800s, American gravestone carvers had forsaken cherubs for the urn and willow as the dominant motif. In fact, the obelisk and statue in the background of this image would soon come into vogue during the late 1800s and early 1900s. Metaphorically, since the cherub no longer had a decorative place on gravestones in 1871, it is only fitting that he has been put to work carving the grave markers. (Courtesy SCIC.)

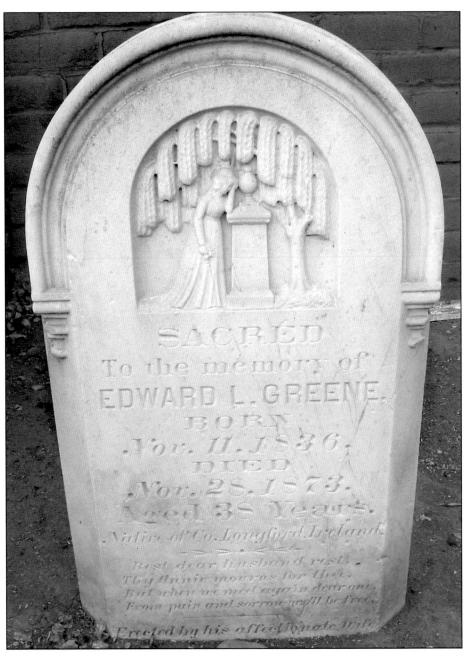

GREENE MONUMENT WITH URN AND WILLOW MOTIF. Edward L. Greene's (1836–1873) El Campo Santo grave marker is a perfect example of mortuary symbology from the 1870s. The secular and somber urn and willow had replaced the religious optimism of the cherub that had dominated grave markers from approximately 1760 to 1860. In addition, epitaph changes mirrored the transformations in grave symbols. The 18th-century gravestones with cherubs typically had uplifting messages that celebrated the soul and the glory of the afterlife. By contrast, late 19th-century grave markers with the mournful urn and willow usually had epitaphs that expressed a heavy heart. For example, Greene's epitaph reads, "Rest dear husband rest. Thy Annie mourns for thee. But when we meet again dear one. From pain and sorrow we'll be free." (Courtesy SCIC.)

	Total Column	Total Tablet	Slant Marker	Bevel Marker	Raised Top	Flush Marker
1951-1960		■	∎	∎	￨	▬▬
1941-1950		■	■	∎	￨	▬▬
1931-1940		■	■	∎		▬▬
1921-1930		▬	∎	￨		▬▬
1911-1920		▬	■	￨		▬▬
1901-1910	￨	▬▬	∎	￨	￨	■
1891-1900	￨	▬▬	∎	￨		■
1881-1890	■	▬▬	▬			

MOUNT HOPE BATTLESHIP DIAGRAM. San Diego gravestones changed in a remarkably regular fashion from 1890 to 1960: they became smaller. Battleship diagrams, with the width of each bar representing the percent of the total gravestones from that time period, show this transformation from tall to short markers. The change occurred gradually and was part of a humbling of the American expression of mortality that resulted from massive losses of life during World War I and the consequent influenza epidemic. (Courtesy SCIC.)

DATING UNDATED GRAVESTONES. The change in gravestone height in San Diego was so regular that it enabled the creation of a predictive model for undated gravestones. If the height of a grave marker is known, then the date of death of the individual it marks can be reliably estimated. This is the equation: Date of death equals 1941 minus one-half the height of stone in inches. The undated gravestone pictured here is 22 inches tall, and thus, was most likely placed in the ground in 1930. (Courtesy SCIC.)

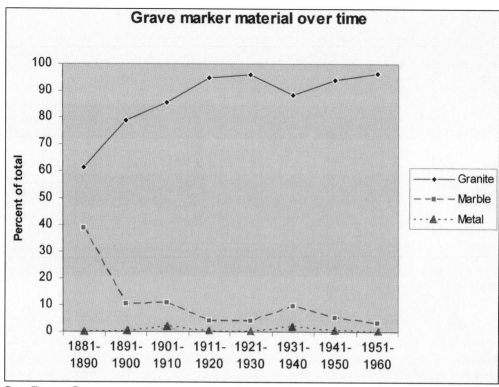

Grave marker material over time

(Line graph. Y-axis: "Percent of total," scale 0 to 100 in increments of 10. X-axis decade ranges: 1881–1890, 1891–1900, 1901–1910, 1911–1920, 1921–1930, 1931–1940, 1941–1950, 1951–1960.)

Legend:
— ♦ — Granite
– ■ – Marble
··· ▲ ··· Metal

SAN DIEGO GRAVESTONE MATERIAL LINE GRAPH. Economic factors heavily influenced the material out of which gravestones were made. This graph shows how sturdy granite markers gradually replaced less expensive and easily weathered marble markers over time with two important exceptions: the early 1900s and the 1930s. These two decades, defined by pronounced economic struggles (the "panic of 1907" and the Great Depression), show an increase in cheaper marble and metal grave markers. (Courtesy SCIC.)

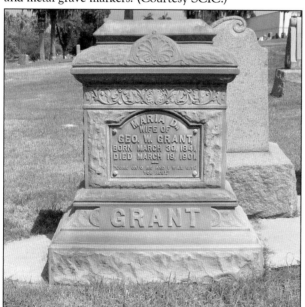

MARIA D. GRANT MONUMENT. It is important to emphasize that the aforementioned gravestone trends are general patterns and that there are numerous exceptions to each one of these rules. The Mount Hope gravestone that marks the grave of Maria Grant (1841–1901) is one of these significant exceptions. It is made of zinc but commercially marketed as "white bronze." The San Diego Gravestone Project has encountered only five of these markers in the entire county. (Courtesy SCIC.)

CONCLUSION

JOHN SPRECKELS. The key to preserving the past is to demonstrate its link to the present. This interconnectedness begins with San Diego's network of relationships. Entrepreneur John Spreckels (1853–1926), the wealthiest man in San Diego, is a perfect example of this local network. He was cremated at Greenwood but has no grave marker, and the location of his cremated remains is now uncertain. Spreckels nonetheless appears repeatedly in between the lines of this text. He bought the Hotel Del Coronado from Elisha Babcock, dated Kate Sessions, and sold his Coronado house to Ernestine Schumann-Heink. Historic San Diego, unlike Kevin Bacon, was not linked by six degrees of separation; it was unified by single individuals like Spreckels, whose name is still ubiquitous in the local landscape (e.g., Spreckels Theater, Spreckels Outdoor Organ Pavilion, etc.). (Courtesy SDHS.)

BUM'S BIRTHDAY CARD FROM DR. SEUSS. In 1986, Dr. Seuss commemorated Bum the Dog's 100th birthday with this card. The material connection between these two local legends unites the city's past and present. Everyone living in San Diego has a link, no matter how ephemeral, to the region's past. We occupy the same space and continue to transform the local environment. For many of us, America's Finest City will also be our final resting place; we too will become San Diego's history. (Courtesy Evelyn Carroll.)

A WORK IN PROGRESS. Perhaps it was the sophisticated research design or perhaps it was the plentiful snacks and belly rubs. Whatever the case, the puppy pictured here was enamored with members of the San Diego Gravestone Project. His youthful spirit symbolizes the work to be done. With over 10,000 historic gravestones in the project database, the study of San Diego's dead has just begun. Is there a link between gravestone size and the wealth of the deceased? Does gender influence the grave-marker motif? Are there distinctive gravestones or mortuary symbols for the region's different ethnicities? How do all of these issues change over time and space? These are some of the many questions that the San Diego Gravestone Project is currently researching in its quest to record and analyze every historical grave marker in the region. (Courtesy SCIC.)

BIBLIOGRAPHY

Aries, Philippe. *Western Attitudes Toward Death*. Baltimore: The Johns Hopkins Press, 1974.

Cannon, Aubrey. "The Historical Dimension in Mortuary Expressions of Status and Sentiment." *Current Anthropology*. 30(4) (1989): 437–458.

Caterino, David M. *The Cemeteries and Gravestones of San Diego: An Archaeological Study*. Unpublished Master's Thesis. San Diego: San Diego State University, 2005.

Deetz, James. *In Small Things Forgotten*. Expanded edition. New York: Anchor Books, 1996.

——— and Edwin Dethlefsen. "The Doppler Effect and Archaeology: A Consideration of the Spatial Aspects of Seriation." *Southwest Journal of Anthropology*. 21(3) (1965): 196–206.

Francaviglia, Richard V. "The Cemetery as an Evolving Cultural Landscape." *Annals of the Association of American Geographers*. 61(3) (1971): 501–509.

Gorman, Frederick, and Michael DiBlasi. "Gravestone Iconography and Mortuary Ideology." *Ethnohistory*. 28(1) (1981): 79–98.

Hijiya, James A. "American Gravestones and Attitudes Toward Death." *Proceedings of the American Philosophical Society*. 127(5) (1983): 339–363.

Mallios, Seth, and David Caterino. "Transformations in San Diego County Gravestones and Cemeteries." *Historical Archaeology*. 41(3) (2007).

Meyer, Richard E. *Cemeteries and Gravemarkers: Voices of American Culture*. Ann Arbor, MI: UMI Research Press, 1989.

Mitford, Jessica. *The American Way of Death*. New York: Simon and Schuster, 1963.

Mytum, Harold. *Recording and Analysing Graveyards*. York, UK: Council for British Archaeology, 2000.

———. *Mortuary Monuments and Burial Grounds of the Historic Period*. New York: Kluwer Academic/Plenum Publishers, 2004.

INDEX

Aller, Charles, 108
Babcock, Elisha Jr., 73
Bradley, Willis Winter, 109
Brannan, Samuel, 68
Bretag, Louisa, 85
Bucher, Lloyd Mark, 110
Buddy, Charles Francis, 95
Bum the Dog, 115, 116, 117, 124
Buono, Victor, 92
Carter, Mason, 107
Cassidy, Rosa Serrano de, 25
Chandler, Raymond, 74
Coors, Joseph Sr., 102
Couts, Cave Johnson, 49
Daniels, Billy, 98
David, Albert Leroy, 109
Eicher, John, 50
Elliott, Robert, 91
Fitch, Henry Delano, 14
Fuller, Walter, 92
Galli-Curci, Amelita, 78
Garra, Antonio, 35, 69
Geisel, Theodor Seuss, 111, 124
Grant, Maria, 122
Grant, Ulysses Simpson Jr., 4, 87
Harrison, Nate, 72
Hinton, Francis, 40
Horton, Alonzo, 71
Hulett, Alta, 68
Jaime, Father Luis, 18
Kerren, Richard, 20

Kettner, William, 88
Kroc, Ray and Joan, 99
Luce, Moses, 89
Mannassee, Joseph, 44, 81
Marshall, William, 36
McPhee, John, 77
Moore, Archie, 79
Morgan, Kate, 70
Nierenberg, William, 102
Otis, Elmer Ignatius, 49
Outcalt, Jasper, 52
Peavy, Hollis and Charlotte, 55
Pendleton, Nat, 78
Robinson, James "Yankee Jim", 37, 69
Rozelle, Pete Alvin, 101
Rutherford, Joseph, 112
Salk, Jonas Edward, 100
Sefton, Joseph, 86
Sessions, Katherine, 73
Schiller, Marcus, 81
Schumann-Heink, Ernestine, 89
Sledzinski, Princess Filomena, 113
Smith, Albert, 106
Spreckels, John, 123
Stallings, Laurence Tucker, 110
Stoddard, Helen, 90
Stone, Milburn, 98
Tanzer, Frederick, 90
Ubach, Father Antonio, 2, 44, 48, 103
Whaley, Thomas and Anna, 37, 69
Wright, Harold Bell, 91

DISCOVER THOUSANDS OF LOCAL HISTORY BOOKS FEATURING MILLIONS OF VINTAGE IMAGES

Arcadia Publishing, the leading local history publisher in the United States, is committed to making history accessible and meaningful through publishing books that celebrate and preserve the heritage of America's people and places.

Find more books like this at
www.arcadiapublishing.com

Search for your hometown history, your old stomping grounds, and even your favorite sports team.

Consistent with our mission to preserve history on a local level, this book was printed in South Carolina on American-made paper and manufactured entirely in the United States. Products carrying the accredited Forest Stewardship Council (FSC) label are printed on 100 percent FSC-certified paper.

MADE IN THE